REMEMBERING

WESTBROOK

REMEMBERING

WESTBROOK

The People of the Paper City

ANDREA M.P. VASQUEZ

Charleston London

THE
History
PRESS

Published by The History Press
Charleston, SC 29403
www.historypress.net

All cover images courtesy of the Westbrook Historical Society.

First published 2010

Manufactured in the United States

ISBN 978.1.59629.960.3

Library of Congress Cataloging-in-Publication Data

Vasquez, Andrea M.P.
Remembering Westbrook : the people of the paper city / Andrea M.P. Vasquez.
p. cm.
Includes bibliographical references.
ISBN 978-1-59629-960-3
1. Westbrook (Me.)--History. 2. Westbrook (Me.)--Biography. I. Title.
F29.W6V37 2010
974.1'91--dc22
2010012460

For my grandparents:

Constance Therese (Richard) Walker, September 1926–December 2007
Howard Warren Walker, February 1922–May 1997
Eleanor Gatchell (Holt) Pacillo, June 1916–February 2008
Antonio "Tony" Pacillo, May 1912–August 2006

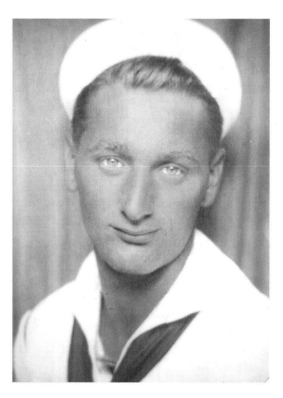

Howard Warren Walker, World War II, circa 1944.
Gunner's mate third class, U.S. Navy. *Author photo.*

Contents

CONTENTS

Acknowledgements

I would like to express my thanks to everyone who provided suggestions, support and assistance for my research for this collection. This work could not have been done without the help of the Westbrook Historical Society, especially Diane Dyer, Donna Conley and Suzan Norton for their ideas and guidance, Byron Dyer for his help on dating photos, Ellie Conant Saunders for additional research help and for providing access to her extensive private collections and Michael Sanphy both for his photographs and for his wealth of knowledge on all matters of Westbrook history.

I am most grateful to The History Press, particularly Brianna Cullen, editor, for helping me through the publication process, and Emily Navarro and Hilary McCullough for their work on edits and production. I am also thankful to the *American Journal* (Westbrook) newspaper (especially former editor Brendan Moran and editor Jane P. Lord) for giving my "History Matters" column a home. Additional thanks must go to the helpful and knowledgeable staff at the Walker Memorial Library, particularly Julie Peterson, curator of the local history collection; Maggie Libby of the Colby Library Special Collections; the staff at the Bowdoin College Archives and Special Collections; Odette LeClerc and Jacklyn Nadeau of the Berlin Coos Country (New Hampshire) Historical Society; Lynne Palmer of

SAPPI North America; Cor Kwant for her ginkgo tree photos and historical information; the staff at the Morrill Public Library in Hiawatha, Kansas; the Brown County (Kansas) Genealogical Society; Michelle Christides for her information on the World War I Signal Corps; St. Anthony's Parish, Westbrook, Maine; Emily Walhout of the Houghton Reading Room, Harvard University; Lesley Heiser, Jean and Abe Peck, Susan Casey and Christine Woods for their feedback; and Carol and Michael Pacillo for their willingness to serve as readers. Thanks also to those at the Maryknoll Mission Center of New York, Jay Silverman, Janet Fraser Mitchell and the families of Sister Therese Grondin, Edmund N. Morrill, Paul Fraser, John Hay and Alice Lemieux Jacobsen for taking the time to share their loved ones' amazing stories with me.

The biggest thanks, of course, must go to my husband, my children and my mother and father for supporting me through the long and wonderful process of putting this collection together.

Introduction

My earliest memories of Westbrook are of morning drives to my grandparents' house, snuggled under a quilt in my mother's unheated Volkswagen Beetle. I made a game of holding my breath as we passed through the low fog of exhaust near the S.D. Warren Company, catching a glimpse of my grandfather's car parked in the employee lot and delighting as we rattled over the Cumberland Mills Bridge. Coming from my efficiently packed beachside suburb of South Portland, the gardens, fields and woods of Westbrook seemed like a country dream straight from *Anne of Green Gables*.

My mother grew up in Westbrook, "the Paper City," as did her parents, but my complete lineage—beyond the Italian ethnicity of those who gave me my surname—was a bit of a mystery. It wasn't until later that I traced my family tree back further, discovering that my first ancestor to settle in Westbrook (then part of Falmouth) came to the Pride's Corner area in 1765. If one believes in such things, of an innate bond to a setting through heritage, perhaps that is where my sense of connection to this city comes from. More likely, however, it originates in my affection for the people of Westbrook, the cool flow of the river, the woods and the strong sense of community within the modern city that I call my home.

Friends and family often ask how I choose the people I write about. After giving that some thought, I have decided to believe it is not I who makes the decision; it is they who choose me. My attention might be drawn by an article, a passage in a book, a bit of overheard conversation or a building I pass on the street. I have absorbed these stories through photo albums, the smell and feel of antique books, the font of yellowed newspaper clippings, the patina on an old church's etched serving plate. For me, history isn't the watered-down, simplified accumulation of dates and facts that we often memorize in school. Instead, real history is the telephone operator who survived a concentration camp in Tunisia, the nurse in the trenches of World War I and the businessman and his mill that created a community.

I recall from a young age paging through my great-grandmother's piles of scrapbooks or sitting at a kitchen table soaking in stories of Portland's Italian community, Westbrook's French-speaking neighborhoods, rivers of wine on the streets during Prohibition, sharing sugar during the Great Depression, letters written to brothers, husbands and sons away at war. I remained silent, almost forgotten, listening attentively to these tales of times long past. The tellers spoke of loved ones who had died, the courageous, the sick and the eccentric. I tucked the details away, hoping that someday I'd find a way to pass them on.

After college and several years abroad, I returned to Maine and made my way to Westbrook— just around the corner from the family homes in which I spent much of my childhood. I married, started my own family and counted myself fortunate to have the chance to renew my relationship with my Westbrook grandmother. We watched cooking programs while she talked about her life. And, an adult now, I finally had the chance to ask questions. Lots of questions.

After she was gone, however, and followed months later by my other beloved grandmother, I realized how many questions remained unanswered, how many anecdotes unfinished.

When a loved one, an elder friend, a community member dies, we who remain behind must ask ourselves this: If we don't unearth our own ancestors' stories and pass them on, who will remember? More importantly, why should we—members of the generation of technology, speed and shortcuts—even care?

Introduction

What pushes me forward, what brings me to the keyboard each day, is knowing that for each article I write, one special person is again given the chance to share his or her story with waiting, eager listeners. And who knows? Perhaps in addition to history buffs like me, some originally disinterested others will flip through the newspaper or this book and get pulled in, too, by a tale of a Civil War prisoner of war or an inventor and his snowball fight. My hope is that anyone who digs into the past, to stories like these, will come away feeling a little more humbled, a little more in awe and deeply inspired by those who came before us.

Mast Agent Who Started War Dies Pauper but Leaves Mark on City of Westbrook

Colonel Thomas Westbrook (1675–1744)

On a warm July day in 1976, several members of the Westbrook Historical Society, a few amateur archaeologists and members of the Knight family of Smiling Hill Farm on the Scarborough-Westbrook line set aside their tools. They had been excavating for weeks, looking to solve a mystery over two centuries old: had they uncovered the secret burial place of Colonel Thomas Westbrook?

Westbrook, who had fallen into financial ruin in the years preceding his death in 1744, had been buried in secret, his body spirited away one snowy night from his Stroudwater home. Many conjectured that his remains had been taken to Portsmouth, the town of his birth, where his wife resettled with their daughter and son-in-law after his death. Others guessed that he had been interred secretly somewhere near his home along the riverbank.

All were incorrect. As the 1976 diggers would soon confirm, his body was taken to the property of his sister and brother-in-law, Mary and Nathanial Knight, in Scarborough. The family passed on that land, as well as the secret of the colonel's grave site, to their descendants, and this knowledge traveled through nine generations, eventually making its way to siblings Frances and Roger Knight by way of their grandfather Benjamin. When the Westbrook Historical Society, of which Roger was (and still is) a member, was looking for

a suitable project for the country's bicentennial, Roger suggested, partially in jest, that they try to unravel the mystery of Westbrook's resting place once and for all.

Because of the project, part of the riddle was indeed solved: the remains, nestled in the woods, set into chipped ledge-stone on Knight's property, were those of the five-foot, six-inch colonel. But a second question remains: who was this man, the man for whom our city was named? For the answer, we must look back to the earlier days of the colonies, of Puritans and pioneers, warfare and hardship, to days before roads, before the bridges connecting the many inlets of our modern state and to days when stately forests, wildlife and powerful tribes owned the land.

Westbrook was born in 1675, the son of English immigrants, in Portsmouth, New Hampshire, at the outbreak of the first great colonial war. With the rise in hostilities between settlers and their Native American neighbors, villages of both parties were razed, family members kidnapped, men and women murdered in their fields. About six hundred New England colonists and three thousand Native Americans were slaughtered in the three years of the bloodiest war on American soil, the first in the series of violent New England wars that would last for almost a century.

Following many decades of peaceful commerce between native tribes and English traders in the territory encompassing today's state of Maine, tensions to the south caused by Massachusetts settlers spreading rapidly into native lands could be restrained no longer. Conflict ensued, and the governor of Massachusetts, fearing that the violence would spread north, issued an edict that trade in powder and shot (upon which the local Native Americans had grown dependent for hunting and survival) must cease.

Though tribal chiefs and Maine settlers protested, knowing that the results would be calamitous, Massachusetts insisted, and several tribes, facing starvation, had no choice but to attack, beginning at the trade settlement at Arrowsic (south of today's town of Bath), where thirty colonists were killed, others captured, supplies taken and the settlement destroyed.

Throughout the years of war that followed, the inhabitants of Maine—both Native and colonial—lived in constant fear of attacks and kidnappings; families lost homes, which were frequently torched in raids; wives lost husbands, who were sent off in battle or killed defending their families; and parents lost children, if not to warfare then to the many fatal

diseases common in those times, including smallpox, pneumonia, scarlet fever and typhoid. Native villages were destroyed, and many settlers left for Massachusetts or abandoned their homes and property to construct and live in sturdy timber and plank garrisons with groups of other colonists during these periods of warfare. Luxuries were minimal, hygiene poor and survival the only real goal, particularly in the smaller settlements scattered throughout New England. Many villages, including that of Portland (previously named Casco by early settlers—from the native Machigonne—and then Falmouth in 1658), were obliterated by the attacks and left abandoned for years.

Charles E. Clark writes in *Maine: A History*:

> *Nearly every settlement in Maine from…Pemaquid to…Berwick, York, Kittery, together with the Dover and Oyster River settlements in New Hampshire, had suffered from quick, fatal raids. Hundreds of houses had been burned and more than 700…settlers either killed or taken prisoner to Canada. East of Wells, the best-defended settlement in Maine, all the former English villages had been abandoned.* [1]

Although Westbrook's family was relatively wealthy, of the "gentleman class," life was by no means easy. Westbrook, born at the start of this violent and disastrous war, would see his rise to wealth and power, and his fall to destitution, many years before the territories of New England would see peace take firm hold. Although King Philip's War (also referred to as the Narragansett War or Metacomet's War) ended in April 1678, peace was fleeting. By the 1680s, friction was growing between the English of northern New England and their French colonial neighbors over the area of Acadia, the territory between the St. Croix and Kennebec Rivers that had been in dispute since 1632.

In 1688, trouble in Europe between deposed Catholic King James II of England, who took refuge in France, and the new leader, Protestant King William of Orange, escalated hostilities in the colonies. King William's War, the first of the French and Indian Wars, had spilled over into the New World by the fall of that year. More bloody attacks ensued between the English colonists and the French with their Native American allies, to whom the land in question rightfully belonged, until peace treaties were signed in 1697 in Europe and, finally, on January 7, 1699, in Casco Bay. [2]

Again, however, peace was short-lived. By the time Westbrook was twenty-seven, he had lived through two devastating wars and was entering into a third. Queen Anne's War, which would carry on for eleven years, erupted in 1702 and again pitted English colonists against French traders and their allies of local native tribes, including the various tribes of Abenaki, who, until forced into such conflicts to defend their land and ensure the survival of their families, had been known as historically peaceful peoples.

Westbrook undoubtedly took part in the protection of his town, Portsmouth, as soon as he reached fighting age. Married to Mary Sherburn, Westbrook also had a daughter, Elizabeth, whom he would have been determined to protect. In 1704, Westbrook applied for commission as a scout and fighter and was given command, as corporal, over several Portsmouth men. By 1712, Westbrook had risen to the rank of captain. Although the European war was ended with the Treaty of Utrecht in 1713—in which the territory of Acadia was ceded to the English—colonial conflicts were far from over.

In 1716, Westbrook was honored by being selected as one of seven members of the King's Council of the Province, a type of governing body in the early colonies, in which he served until 1730. He often found himself unable to attend council appointments, however, as raids continued sporadically and often called him away from home.

Small clusters of English settlers were scattered around Maine in such areas as Wells, Brunswick, Merrymeeting Bay, York, Kittery and several parts of the current city of Portland. Distances were great between neighbors, with a parcel of land often equaling one thousand acres. A sense of community, however, was more than just pleasantry: life often depended on alliances. Settlers joined together, still frequently forced to retreat to closed-in stockades, or even nearby islands, for protection during periods of war.

In December 1719, Westbrook was sent to Casco Bay to meet with local tribes, reportedly to try to talk out troubles, which had begun to escalate again due to often hostile settlers encroaching on native land. The talks, however, were unsuccessful. Conflict again erupted in 1721 with Dummer's War (also known as Lovewell's War), another four-year series of violent raids and bloodshed in northern New England settlements between the colonial British and their Native American and French neighbors.

In an attempt to end the conflict, in January 1722, Westbrook was given command of a regiment of over two hundred men who sailed and marched toward Norridgewock, a tribal settlement where lived an educated and dedicated French Jesuit, Father Sebastian Rasle, whom the British suspected of inciting violence on the English settlements in Maine and New Hampshire. Westbrook was ordered to capture Father Rasle and transport him to Boston.

The conditions in the January forests of Maine, however, made the trip slow and laborious, and by the time the troops arrived the following month, Rasle had already made his narrow escape. Found, however, was a chest belonging to the priest that contained letters from the government at Quebec, which, whether valid proof or not, were used as evidence that the British suspicions against him had been accurate. Also included in the box was a dictionary of the Abenaki language that Rasle had been working on over the twenty-five years that he had spent as a missionary and friend of the tribe at Norridgewock in the settlement close to today's city of Skowhegan. This document, as well as some Rasle's transcribed letters, is currently in the collections of the Houghton Library of Harvard University.

The degree of Rasle's guilt was questionable, but suspicions were not completely unfounded. In a letter written in his own hand, Rasle confirmed that while he would never incite warfare against the British, he would not prevent his religious followers from pursuing it if their lands and lives continued to be robbed by the colonists.[3]

Accounts differ as to the reaction of Westbrook's invading troops, forced to leave Norridgewock without having captured the priest. Some records say they left peacefully, while others claim that they destroyed the village, which, sadly, seems the more likely version in these times of fear and violence.

Several more attempts were made to capture Father Rasle, and, as might be expected, the French and the tribe of Norridgewock retaliated with raids that destroyed several English settlements, including that of Brunswick. In 1723, with war firmly underway, Westbrook was given command of the colonies' eastern district forces and promoted to the rank of colonel.

This conflict came to a vicious end when, in August 1724, over two hundred English militiamen made one last attempt at the capture of Rasle. Due to the season, many of the tribesmen were away at this time in the fields, and word of the English arrival did not reach the village in time. Westbrook was not present at this raid, but it ended in the massacre of at least twenty-

eight, many of whom were women and children. Among them was Father Rasle, whose scalp was brought back to be paraded through Boston.

Westbrook's military career drew to a close shortly after this; his last recorded presence in a military capacity was at the signing of the peace treaty with representatives from the Penobscot and other eastern tribes as well as a large group of government officials from Massachusetts in Falmouth in the summer of 1725. The once powerful tribe at Norridgewock was certainly no longer a threat to colonial expansion. So disturbed were the remaining tribespeople by the death and destruction that awaited their return from the fields that previous summer that they reportedly removed to the area near Quebec for permanent resettlement.

The resulting peace that fell on the areas of Stroudwater and Falmouth was slightly more enduring than the previous periods of calm in New England and would last, for the most part, until just before Westbrook's death fifteen years later. Because of this peace, settlers spread in greater numbers toward Falmouth, including Stroudwater and the area that now comprises the city of Westbrook. In 1725, the area got its first permanent minister, Reverend Thomas Smith, and by 1726, about sixty-four families were gathered together in the Stroudwater area alone. And this is where Westbrook, by then a man of more than fifty, chose to establish himself for business.

In 1727, Westbrook, retired from his official military duties, was named mast agent of King George II, who had inherited his kingship in June of that year. The forests of Great Britain had long been depleted of timber large enough and strong enough to serve as masts for the growing ships of the Royal Navy, but New England's unblemished woodlands, with plentiful great white pine, were a perfect gathering ground for the masts. Westbrook soon made his fortune in the masting trade, but it was, like most endeavors in colonial times, extremely hard work. Westbrook was required to hunt the forests for white pine of suitable size (measuring as many yards in length as it did in diameter at the butt)[4] and mark each tree as property of the king, shown with the "Broad Arrow," three axe cuts forming an upward pointing symbol.

He would then handle the cutting and hauling and accompany the trees to the Dunstan and Stroudwater landings, ensuring their safe arrival. Reaching these giant trees in the wilderness also involved road and bridge

construction, building and mending dams, locating and keeping oxen for the purpose of hauling the heavy timber, finding and providing for the skilled and very strong workers—axes were the only tools used for felling at this time—and protecting marked trees until gathered. So valuable were the mast trees to the Royal Navy that the timber was regulated by king's law in New England as early as 1691, and the Broad Arrow Act later passed in 1729, making it a heavily finable offense to cut down a marked tree for any purpose other than masting. Of course, this did not always stop settlers in need of timber for shelter and Native Americans, who certainly weren't bound by English laws, from trying.

Unlike many before him, Westbrook was not an absentee profiteer. He officially settled in Stroudwater in the summer of 1727, uprooting his wife from her (comparatively) comfortable Portsmouth community and leaving behind his daughter, then married, and grandchildren. He began construction of his modest home, which he named Harrow House in English manor tradition, in a location today found on Stroudwater's Westbrook Street, and had settled there permanently by 1733. The home, as was suitable for a community leader of military background, was fitted with a sturdy timber garrison and used as a gathering place for community members during raids, which still continued—perpetuated by both colonists and retaliating tribes—even in times of "peace."

Westbrook adapted to life in Stroudwater quickly, and his profits in masting were sizeable. He eventually began to look for a business partner for other enterprises in the expanding southern Maine settlements and found an unlikely associate in General Samuel Waldo, the thirty-one-year-old nephew of a good friend of Westbrook, Cornelius Waldo, a German immigrant who had Anglicized his name from von Waldow upon his arrival in Boston. Though a shrewd and very prosperous businessman, the ruthless young Waldo (later responsible for the ruin of close to eighty German families he had convinced to immigrate to Maine in order to settle his land)[5] would eventually be the downfall of the already middle-aged Westbrook.

At first, business was booming: the partners bought up land, by some accounts as much as fifteen thousand acres, including all of the falls of the Presumpscot from Gorham to Falmouth. They then began construction of sawmills as well as the first paper mill in Maine, followed by several others in the Stroudwater area. It was the construction of a dam at the lower falls

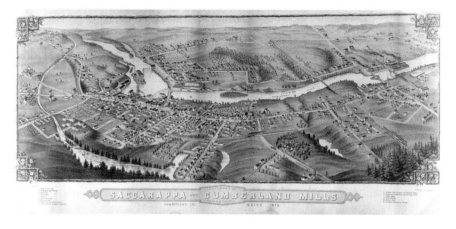

The Saccarappa and Cumberland Mills villages were part of the original township that separated from Falmouth in 1814 and was named in honor of Colonel Thomas Westbrook. *Courtesy of the Westbrook Historical Society, Warren Memorial Library Photographic Collection.*

of the river, however, in connection with the mills, that reportedly brought about new tensions with the native tribes along the Presumpscot, dependent on the salmon migrations for winter sustenance. Westbrook's initial dam was destroyed in a raid, and his first paper mill was never in full operation.

Other dams and mills followed quickly, however, including one at Saccarappa Falls in 1738. A local chief of the Sebago area (known by historians as Chief Polin, a decidedly unnative name), whose tribe had been most affected by the damming of the river, soon protested. The chief walked to Boston to speak directly to the governor of Massachusetts, who agreed that fish-ways would be installed in the dams to allow the migration of the much-needed salmon and alewives.

The fish-ways, however, could not counter the influx of settlers along the Presumpscot, which further decreased the natural fish population and led to dire conditions among the Presumpscot area tribes. After further protest and another trip on foot to Boston, without satisfaction, Chief Polin declared that tribes would have no choice but to drive out the settlers themselves, and war, again, ensued.

At the same time, business began to go bad for Westbrook, by then a man of more than sixty. He was sued by Waldo and, although reportedly without representation at a trial arranged by his former partner, lost the sizeable amount of joint property he had acquired during their affiliation.

In 1743, Waldo further sued Westbrook, by then in much-failing health, and won again through (reportedly) rather shady legal procedures, resulting in Westbrook's loss of everything, including his mills, landholdings and his home, the Harrow House.

Westbrook fell ill and died on February 11, 1744, in Stroudwater, without even a burial plot remaining in his name. Debts of £3,000 lingered at his death, and it was because of this that Westbrook's family was forced to spirit him away in the middle of the night and keep his resting place a secret, a secret that would endure for 232 years.

English customs, and perhaps even English law, at the time allowed for the body of a debtor to be held hostage until financial obligations were met, a requirement that seemed nearly impossible for Westbrook's family to achieve due to the size of his debts and the meager remnants of his estate. To prevent the once great and heroic Westbrook from being submitted to such treatment in death, his family hid the body in the woods on his sister's property, a patch of ledge chipped away in the night to make room for his coffin.

A plaque was laid in his honor, albeit buried with his crude wooden casket. It was this hidden marker, which read "mas Wes...70 yrs," that would, over two centuries later, in 1976, help confirm the colonel's identity to his descendants and the group of hot, tired historical society members who had made it their mission to solve the mystery of Colonel Westbrook once and for all.

Businessman's Generosity Has Lasting Impact

Joseph Walker Jr. (1800–1891)

Without the generosity of Joseph Walker Jr., the city of Westbrook would be without one of its most important and architecturally distinct features: its 1894 municipal library.

Although a limited social lending library had been established in the community in 1802, it was inactive at the time of Walker's death in 1891. In fact, the modest literature collection remained unused in the volunteer librarian's basement. This librarian, Fabius M. Ray, was also Walker's attorney. With Ray's assistance and encouragement, Walker drafted a will that would bequeath, among other generous gifts, $40,000 (equivalent to about $1 million today) to the City of Westbrook for the construction of a public library.

A man with a keen business sense, Walker acquired his wealth through a diverse series of ventures in industry and commerce, from lumber and farming to banking. Although Walker suffered great economic and personal losses in the 1830s, he continued to pursue his dreams, and to great success.

Joseph Walker Jr. was born in Denmark, Maine, on February 7, 1800. He was the son of Mary (Foster) and Captain Joseph Walker, a businessman who dealt in lumber and real estate and had investment connections to the Cumberland-Oxford Canal. For reasons reportedly linked to the War of

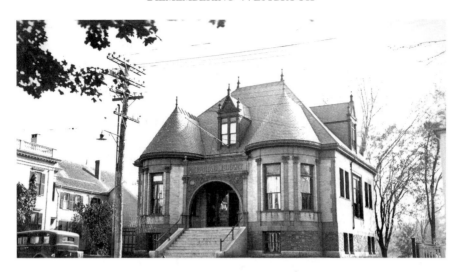

The Walker Memorial Library, circa 1934. *Courtesy of Michael Sanphy.*

1812, when Walker was twelve years old, the family "traded farms" with Joseph Pride of the Pride's Corner area and transferred to Westbrook.

While his father spent much time away on business, Walker, along with at least one known sibling, Benjamin, was left to take care of the farm. Walker's formal education was thus cut short, something he would lament throughout his life. Walker assisted with the farm until the age of seventeen, at which time he decided to undertake his first personal business endeavor. He bought a horse and cart and became a peddler, selling goods to local residents for several years.

Although his family transferred to Portland at this time, Walker remained in Westbrook and married at the age of twenty-four. His bride was nineteen-year-old Eunice Carter of Boston. Sadly, any newlywed happiness was short-lived. Just two years later, at the young age of twenty-one, Eunice died. The couple had no children.

Walker likely immersed himself in his work at this point and, in 1830, purchased a sawmill in the Great Falls area of Windham with a business partner named Peter Trickey. Business went well at first, and in 1834, Walker married Ann Johnson of Windham, a descendant of George Tate (Tate House) of the Stroudwater area of Portland. Known for her beauty and intelligence, she was to be his companion until her death in 1889.

But Walker's path was not without further obstacle. In 1837, the country was hit by its first large-scale economic depression, which has been referred to as "The Panic." About one-third of the country's banks were forced to close, while others called in loans and cut off credit. The economy grew stagnant. Due to these national hardships and a lack of capital, Walker and Trickey's business crumbled and the partnership dissolved.

Instead of conceding defeat, Walker relocated to Saccarappa in 1838 to open another sawmill. Fortunately for Walker, this time his business went very well. When his lumber interests took off, he was able to branch out into everything from dam repair and canal deepening to mill construction and land surveying.

In 1855, Walker transferred to Portland, moving into a home on High Street. There, his reputation as a shrewd businessman allowed him to become involved with numerous successful enterprises with others, including the Westbrook Manufacturing Co. and the Portland Gas Co. He held roles as diverse as lender, investor and property and capital manager. He also functioned as director of several banks, including Casco Bank, where he served for thirty-two years.

Through these efforts, he became even more prosperous. Although he remained childless, he shared his home at various points with nieces and nephews, children of his elder brother Benjamin of Bridgeton, who had also had success in the lumber business.

As Walker grew older, he began to look for ways to use the money he had acquired to benefit the community. He expressed his interest in assisting with hospitals and other publicly beneficial institutions, but especially toward schools, libraries and scholarship awards. Despite his great success, Walker reportedly always wondered what his life might have been like if he had had the benefit of a more extensive education.

When Walker died in 1891, just two years after the loss of his wife Ann, his wish to help the community was soon realized. Walker willed funds for the Portland library as well as to the City of Portland to allow for the construction of the Walker Manual Training School. This was the state's first such vocational institute, which trained young people in manual and technical skills. The school, located on the corner of Casco Street and Cumberland Avenue in downtown Portland, was part of the public school system from 1901 until the early 1970s.

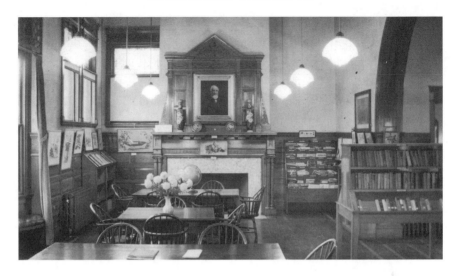

The Walker Memorial Library reading room, circa 1934. The portrait of Joseph Walker still hangs over the fireplace today. *Courtesy of Michael Sanphy.*

Walker's most memorable gift—and that which has most benefited the people of Westbrook for the last 115 years—was the gift of $40,000 for the construction of a public library, with any remaining funds to be put in trust and used for the purchase of books.

Although it was his stated wish that his name not appear on the building, the City of Westbrook decided in the mid-1930s that this generous man should nevertheless be remembered for his gift. Thus, as a Westbrook municipal library card will attest to today, the magnificent building and institution that was once christened simply the "Memorial Library" was more appropriately designated the "Walker Memorial Library."

Legacy of City's Benefactor

Samuel Dennis Warren (1817–1888)

For over forty years, my grandfather worked at Westbrook's S.D. Warren mill. After his own father died there in a train accident in 1929, his mother became a paper sorter for the company. His grandfather and uncle were also foremen at the mill until the 1950s, and it was even through the mill that my grandparents first met.

Most Westbrook residents have similar family stories; for many years, Warren Standard Paper *was* the city of Westbrook, from the strong pulpy smell to the bold black letters on the giant smokestack over the Presumpscot River. More than a few of us have an ancestor named "Warren" after Westbrook's largest employer—and one of the most benevolent business owners of the nineteenth century. Indeed, it was Samuel Dennis Warren who introduced labor management policies at the Westbrook mill that would help revolutionize concepts of labor relations in the United States.[6]

These policies and his well-known philanthropic contributions toward the community also helped transform Westbrook from several modest villages (then Saccarappa and Cumberland Mills) into a thriving manufacturing district.

Warren's beliefs and business sense that led to his great success, and the growth and development of this southern Maine city, likely came from his

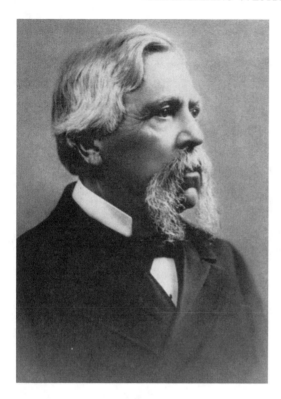

Samuel Dennis Warren, circa 1875. *Courtesy of Michael Sanphy.*

upbringing and early life experiences. Born in Grafton, Massachusetts, in 1817, the sixth of fourteen children, he was the son of a skilled Yankee trader and a mother who stressed the importance of education and religion. Warren's father died in 1828, when Warren was only eleven. Despite this hardship, his mother remained steadfast in her commitment to education for her children. Warren attended village schools for his elementary years and was later sent to academies in Groton and Amherst.

Although his mother wished him to attend college as well, at age fifteen he decided that business was his calling. He found employment as an office boy at Grant & Daniell, a Boston paper dealer and supply store. Over the next few years, Warren worked in many positions and learned all aspects of the business. His employers must have realized his great value to the company, as they invited him to become partner, with no monetary investment, when he was only twenty-one.

Warren and his partners decided to branch out in the paper business and become directly involved in manufacturing in addition to sales and

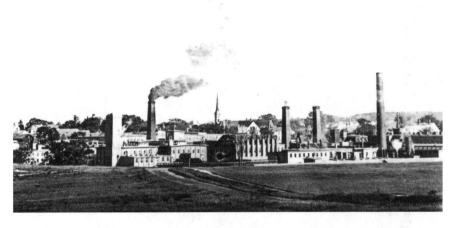

S.D. Warren Company, circa 1875. *Courtesy of Michael Sanphy.*

distribution. They bought the small Day & Lyon paper plant in Cumberland Mills, Maine, in 1854 for $28,000.

About a decade later, his partners sold their shares, and Warren became sole proprietor. The mill's name then changed from Grant, Warren & Co. to the S.D. Warren Company.

Throughout this time, religion remained extremely important in Warren's life. He was deeply pious and is said to have attended up to five church services each Sunday and at one time even considered joining the ministry.[7]

As can be shown from his stewardship in Westbrook and unusually generous treatment of his employees, Warren believed that it was a person's duty to be unselfish with his wealth and use it for the benefit of others.

Warren was recognized throughout the state for his liberal wages, limited night shifts and refusal to employ children, a practice that was still common in mills. While ill-kempt tenements and boarding homes were the norm for employee housing elsewhere, Warren kept neat cottages (many of which are still present on Westbrook's Brown and Cumberland Streets) available to workers for very low rent.

Much to the surprise of industry leaders who prescribed to a conflict model of labor relations, holding that interests of workers and employers were incompatible, Warren managed to turn this small two-machine mill on the Presumpscot into the most successful paper manufacturer in the country.

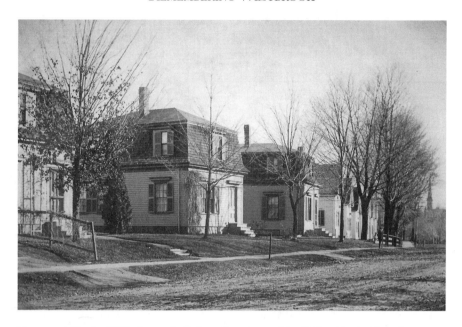

Constructed in the 1870s, homes built for millworkers originally lined both sides of Cumberland Street, Brown Street and Cottage Place. These homes on Cumberland were eventually torn down to make way for mill expansion. *Courtesy of Michael Sanphy.*

The mill had progressed from producing three thousand tons of paper per day to over thirty-five thousand in 1880.

At the time of S.D. Warren Co.'s successful growth, the rest of the nation's manufacturing industry was facing great unrest. High levels of worker discontent led to decreased production and overall turmoil within the industry.[8] Workers had much reason for frustration. Most U.S. employers viewed them as expendable commodities. They faced long hours, inadequate wages, unsanitary conditions and overall poor treatment in the workplace.

Tension between laborers and employers increased as workers found ways to organize and protest. According to research by Charles Scontras of the University of Maine, there were about one hundred labor strikes in this state alone between 1862 and 1882. Reports indicate that there were over twenty-two thousand strikes in the country in the subsequent decade.[9]

Washington responded to the strife with the formation of the U.S. Senate's Education and Labor Commission. Warren quickly drew the group's attention. While labor disruption was widespread, Warren's own company

had witnessed no strikes at all and only one insignificant example of mild worker unrest.

Thus, in 1883, Warren was invited to speak before the assemblage about his atypically benevolent management practices.[10] It became clear to those in attendance that Warren took an unusual personal interest in his workers and that he held a strong belief in the humane and respectful treatment of others. But treating employees well, he advised the commission, was also good for business—as fairly treated workers would be more loyal, more productive and more invested in the company's success.

Although it wasn't until the 1920s that policies similar to Warren's truly flowered in the United States, Warren, along with a few others, is credited with pioneering the magnanimous business strategies that would become known as "welfare capitalism."

A pioneer in the pulp and paper industry with respect to innovation, trade and labor management, he continued to help the town of Westbrook throughout his life and passed on this tradition to his wife and five children.

Warren funded the construction of schools, churches and community meeting centers and established a mutual relief fund for disabled mill employees and families of deceased workers. In addition to providing low-rent housing, he offered low-interest loans to encourage employees to purchase and construct their own homes.

Warren also took the unusual step of establishing a reading room within the mill, knowing that many of his workers had not had the benefit of extensive schooling. Furnishing it with volumes from his own collection as well as many of the books printed on Warren paper, he invited employees to read there between shifts and after work.

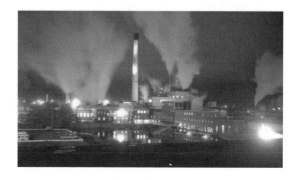

A night view of the S.D. Warren Company, circa 1970. The towering smokestack was added to the facility in the 1920s; each painted letter in WARREN STANDARD PAPER stood six feet high. *Courtesy of Michael Sanphy.*

Warren took pride in the library and, upon his death in 1888, left it in the care of his equally dedicated wife, Susan Clarke Warren. She and her children expanded upon the collection, donating books of their own and, as Warren had, continuing to contribute to the city and other New England organizations in important ways.

In addition to significant contributions to the Boston Museum of Fine Art and other establishments, in memory of her husband, Mrs. Warren willed the mill library (which became the Warren Memorial Library) to the community in care of the Warren Memorial Foundation, along with an endowment of $130,000[11] to be used for educational and art-related purposes.

The Warren Memorial Foundation, until the spring of 2009, functioned to sustain the library and to manage the endowment that had for many years supported various important educational programs within the community, keeping Samuel Dennis Warren's name, and well-deserved legacy, alive in Westbrook.

Sculptor's Quest for Beauty Cut Short

Benjamin Paul Akers (1825–1861)

T urn-of-the-century sculptor Benjamin Paul Akers was once called "the most famous native of Westbrook." As the years passed, however, the great artist has been all but forgotten.

Akers was known in art circles for his medallions, portrait busts and a number of stunning, free-standing sculptures, two of which were "borrowed" by Nathaniel Hawthorne for his novel *The Marble Faun*. Sadly, Akers died at the height of his brief career at the age of just thirty-six. Many viewers of his masterpiece, the breathtaking *The Dead Pearl Diver* (1858) at the Portland Museum of Art, have imagined that, had he lived, he would have become one of the country's greatest names.

Akers was born in Westbrook in the historic Conant house on July 10, 1825. He was the oldest of eleven children in a family of modest means. Akers, known early on by playmates as a dreamer, received a humble and somewhat broken early nineteenth-century village education.

When Akers was eighteen, his father moved the family to the Salmon Falls area of Buxton/Hollis to farm and eventually open a wood turning mill. It was in his father's shop that Akers first began to experiment with carving, crafting small ornamental pieces out of the wood from the mill with simple

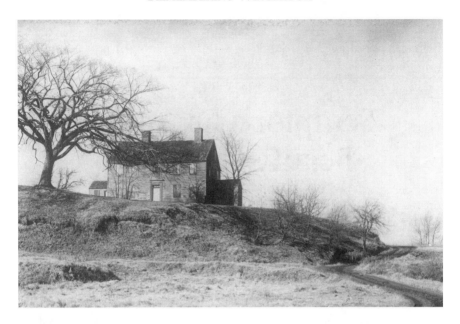

The birthplace of sculptor Benjamin Paul Akers, the original historic Conant house on Park Hill, circa 1880. *Courtesy of the Westbrook Historical Society, Warren Memorial Library Photographic Collection.*

carpenters' tools. The elaborate patterns and decorative woodworking that he created were evidence of a surprising natural talent.

Akers soon took a job in a Portland printing shop, working as a typesetter in the Exchange Street office. It was here that he spotted a bust done by Edward Brackett, another Maine-born sculptor, and was so struck by it that he decided that, at all costs, he must become a sculptor.

Shortly after, Akers moved to Boston to take up study with skilled artist Joseph Carew, where he learned the art of plaster casting. Upon return to Maine about a year later, he began to work in his family's Salmon Falls home and then in space offered by the village physician, Dr. Swett, a friend and great admirer of Akers's work.

His first independent works were a *Head of Christ*, which was later ordered in marble by the U.S. minister to The Hague, and a medallion rendition of Dr. Swett, jokingly referred to by Akers as "as ugly as Fra Angelico's devil, but a remarkably faithful likeness."[12]

Due to his evident talent, Akers was discovered by John Neal, a well-known Portland writer, literary critic and patron of the arts. Neal

helped Akers open a Portland studio and encouraged patronage from other area notables.

Akers completed portrait busts of a list of prominent citizens, including Neal himself, Governor John T. Gilman of New Hampshire and Henry Longfellow. So gifted was the young sculptor that it soon became local fashion to "sit for an Akers marble."[13]

In 1852, Akers realized the dream of any artist: to travel to Europe to study the work of the masters firsthand. He found studio space in Florence, the city of Michelangelo's birth, and spent the next year working and studying the Medici sculpture galleries and loggia collections of great works by Renaissance masters.

Akers returned to the United States with new energy. In 1853, he completed his well-known *Benjamin in Egypt*, which was exhibited in that year's World's Fair in New York. In a tragic blow to both Akers and the world of American art, this work was destroyed the following year in a fire that burned the Portland Exchange Building where it was housed.

In 1854, Akers won a silver medal for his bas-relief, *Peace*, at the 1854 Exhibition and Fair of the Maine Charitable Mechanic Association. He then spent some time in Washington, D.C., completing portrait busts for a number of important political figures, including President Franklin Pierce.

From a studio in Providence, Rhode Island, he continued his portraiture work and received a sizeable commission from Providence millionaire Edward King. Six of the resulting sculptures are today housed in the historic Redwood Library in Newport.

In 1855, Akers returned to Europe, this time with his younger brother Charles (also a sculptor), spending time in Paris and Switzerland before crossing the Alps on foot and returning to Italy, where he took up a studio on Via Delle Crecie in Rome.

Here, he studied under Hiram Powers, a well-known neoclassical sculptor, and created his most famous works, including his *Head of Milton* (today in the Chapman Room of the Colby College Library's Special Collections). He also sculpted a full-body copy of the Roman *The Dying Gaul* and a *Cicero Head*, modeled on a damaged artifact then stored in the Vatican. Today, both of these Akers works are in Newport's Redwood Library.

It was also during this period in Rome that Akers completed the magnificent *The Dead Pearl Diver*, which was to be the first acquisition of

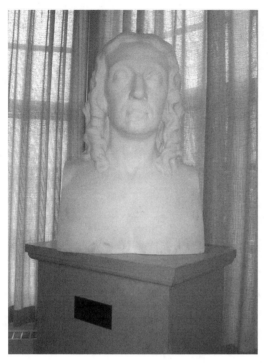

Akers's *Head of Milton. Courtesy of the Colby College Special Collections.*

the Portland Museum of Art (then the Portland Society of Art). *The Dead Pearl Diver* is a marble representation of an ideal youth drowned at sea while seeking the perfect pearl. With the delicate features of the face and body, the beautifully worked fishnet drapery and the details of tiny shells and seaweed entwined in the net, this sculpture brought Akers to the peak of his success.

Also while in Rome, Akers became associated with the Anglo-American colony, which included Robert and Elizabeth Browning and Nathaniel Hawthorne. Hawthorne greatly admired Akers's work, and the two became friends. In addition to including detailed descriptions of *Head of Milton* and *The Dead Pearl Diver* in his *The Marble Faun*, Hawthorne is said to have based the novel's main character, Kenyon, on the quiet, gentle Akers.

Akers returned home in 1858 in poor health, perhaps due to exhaustion caused by long hours spent in his damp, sunless Roman studio. Despite his failing health, Akers continued to work, producing busts, bas-reliefs and medallions, and contributed art-related articles to New York's the *Crayon* and the *Atlantic Monthly*.

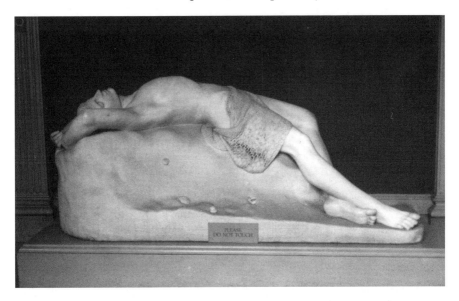

An early photograph of Akers's masterpiece, *The Dead Pearl Diver*, today housed in the Portland Museum of Art. (Photo late 1800s/early 1900s.) *Courtesy of Michael Sanphy.*

He returned to Italy in 1859, with a commission for a statue of U.S. Naval Commodore Matthew C. Perry (who had negotiated the opening of isolationist Japan for trade with the West in 1854) for New York's Central Park. This work, however, was left unfinished. Akers was forced to return to the United States in 1860 in an attempt to regain his strength.

This same year, he married his longtime sweetheart, poet and newspaperwoman Elizabeth Taylor—who would later gain literary fame under the name of Elizabeth Akers Allen. Akers died shortly after, on May 21, 1861, like his pearl diver, cut short while seeking the perfection of beauty.

Young Pioneer, Abolitionist Heads to Kansas, Becomes the New State's Thirteenth Governor

Edmund Needham Morrill (1834–1909)

When the Kansas-Nebraska Act was passed in 1854, the entire country was apprehensive, particularly the citizens of the North. Unlike the Missouri Compromise of 1820, which led to Maine being admitted to the Union as a free state and Missouri becoming a slave state—maintaining the precarious balance between the factions—the Kansas-Nebraska Act would permit the settlers of those territories, upon gaining statehood, to decide if they would allow slavery. This would thus overturn the Missouri Compromise by legalizing slave states above the 36°30' north latitude (the southern boundary of Missouri), which the previous law forbade.

Although Nebraska was far enough north not to cause much worry, many northerners assumed that Kansas residents would sympathize with their southern proslavery neighbors. Along with a number of others interested in keeping Kansas free, a group of New England abolitionists called the New England Emigrant Aid Company decided to take action. By 1855, over one thousand pioneers associated with this group had moved to Kansas's rough and wild land in order to cast their votes and help bring the new state into the Union without the weight of slavery.

Among those New Englanders was a courageous twenty-three-year-old Westbrook native named Edmund Needham Morrill. Within the first few

years of his move, he would become a member of the first free legislature of Kansas, lose his livelihood in a disastrous fire and fight in the Civil War as a major in the Union army. Following the war, Morrill would spend the rest of his life in his adopted state, becoming a successful businessman and generous philanthropist while serving for four terms in the U.S. Congress and, eventually, as the thirteenth governor of Kansas.

Morrill was born in Westbrook on February 12, 1834, the son of Mary (Webb) and Rufus Morrill, a local tanner. He graduated from Westbrook schools and Westbrook College (then known as Westbrook Seminary School) in 1855 and then began working with his father. He ventured into local politics in 1856, when he was elected to Westbrook's board of school supervisors.

Morrill's three-year term with the school board was cut short when, in March 1857, he decided to join the New England pioneers in Kansas. Although his political/moral goal was to make the state free, his business ambition was to become an entrepreneur and establish a sawmill in his new home. He brought the necessary materials with him from Maine and settled in the small village of Hamlin, Kansas.

In 1860, however, the state was faced with drought, and the dry conditions led to a fire that burned Morrill's sawmill to the ground. He lost everything, and according to reports, it took him many years to recover from the financial upset.

At the same time, the territory was in the midst of a slavery dispute so violent that it became known as Bleeding Kansas. As abolitionists and others with Free State interests flocked to the territory, southerners were outraged. Proslavery Missourians referred to as "Border Ruffians" poured into Kansas to cast illegal ballots each time a vote was to be held. Many lived up to their nickname, bringing violence against the Free State proponents: tarring and feathering, beatings and killings ensued.

Despite the fact that a large percentage of votes was cast by nonresidents, the proslavery faction won a number of important elections, and the resulting legislature made into law several harsh statutes that northerners referred to as the "Bogus Laws." These included penalties of death or hard labor for anyone caught assisting a fugitive slave.

In response, the antislavery settlers set up in Topeka their own free state legislature, of which Morrill became a member shortly after his move in

1857. The two Kansas legislatures essentially worked to cancel each other out, but much to the dismay of the North, President Franklin Pierce only recognized the proslavery government. Although the two Kansas legislatures tried repeatedly to gain admission as a state—both free and slave—it wasn't until the secession of the South that it finally gained entry into the Union as a free state.

At the outbreak of the Civil War in 1861, Morrill enlisted on the Union side in Company C of the Seventh Kansas Cavalry as a private. Just five days later, he was promoted to sergeant, and the following year President Lincoln named him "commissary of subsistence" in Mississippi and General Ulysses S. Grant put him in charge of military stores at Forts Donelson and Henry. Morrill later fought at the Second Battle of Corinth, a long, hard fight over a crucial Mississippi segment of railroad that resulted in the loss of over seven thousand American men.

However, there were some brief moments of joy, even at wartime, for the young Morrill: while still enlisted, he traveled back to Maine to marry Elizabeth Brettun of Livermore. At the end of the war, the couple resettled in Hiawatha, Kansas, but sadly, the young bride fell ill and died several years later in the fall of 1868.

After his experiences in the bloody war and the loss of his wife, Morrill did his best to pick up the pieces and discovered he could do much good for his country and state through politics. As soon as Morrill returned to Kansas, he was elected court clerk, county clerk and then to the state senate in 1872, where he served for six years. He also served in the U.S. House of Representatives from 1883 to 1891, where he worked to protect and provide for U.S. veterans with legislation such as the Morrill Dependent Pension and Disability Act.

While his political career was just beginning in the 1870s, Morrill began to invest in land and property throughout Brown County. He also partnered with several others to open the banking firm of Barnett, Morrill & Co., which later became the Morrill & Janes Bank, and of which he became sole proprietor in 1896. By this time, he was rated a millionaire, a rare achievement in his era.

After Morrill completed his eight years in Congress, he reportedly decided to retire from politics. Kansas supporters, however, pressed him to continue, and in 1895 he was elected as the thirteenth governor of the state. In the term

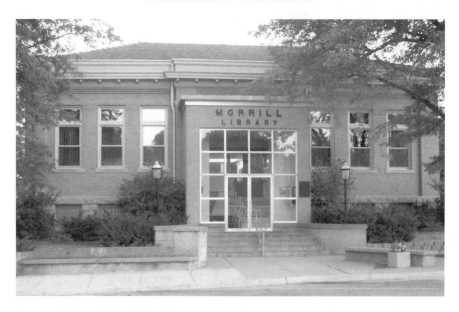

Governor Edmund Morrill deeded property to the city for the establishment of what would become the Morrill Library in 1906. *Courtesy of the Morrill Library, Hiawatha, Kansas.*

he served in office, he pushed the state forward in industrial development, irrigation and antitrust amendments to the Kansas State Constitution.

Although Morrill overwhelmingly won the Republican nomination for the subsequent gubernatorial election, he lost the general election and officially retired from politics. He then dedicated himself to his business interests, which included his appointment as president of the First National Bank of Kansas City, as well as to several philanthropic ventures that greatly benefited the citizens of his hometown, Hiawatha.

In 1882, Morrill founded there the Morrill Free Library, for which he deeded property to the city in 1906. He also donated land and $10,000 (equivalent today to about $237,000) for the establishment of Hiawatha Academy, the first such seminary college in Kansas, which was open to both young men and women.

While still a young man, Morrill remarried to Caroline Nash of Boston and had three children, Frank, Susan and Grace. By 1909, at the age of seventy-five, Morrill and his wife were both in failing health. They traveled to Texas in hopes that the climate and air would prove beneficial, but Morrill remained weak and died, in the care of his son Frank, on March 14 of that same year.

The People of the Paper City

Kansas, particularly Brown County and his hometown of Hiawatha, has not forgotten Morrill's generous contributions to the state and cities and his experiences as a politician, pioneer and veteran. A tiny town thirteen miles northeast of Hiawatha—and very near the town of Hamlin, in which the twenty-three-year-old abolitionist/entrepreneur first settled—speaks to the deep respect and admiration felt for him by Kansans. Shortly after his death, that town was named "Morrill" in his honor.

Historian Told City's Story through Research

Fabius Maximus Ray (1837–1915)

Many in the Westbrook community have heard of the generous Joseph Walker, who in 1894 willed a significant portion of his wealth to the city for the construction of the Walker Memorial Library. Fewer remember the name of another who played a significant role in the library's history and the history of Westbrook itself: Fabius Maximus Ray. A well-known lawyer, poet and local historian in the 1890s, Fabius Ray also volunteered as librarian for the fading Westbrook Social Library. This library, founded in 1802, then consisted of little more than a few cases of literature stored in his home.

According to a family letter, when Joseph Walker, one of Ray's legal clients, informed him of his intent to bequeath funds to the community of Westbrook, it was Ray who proposed designating the sum toward a community library. The idea appealed to Walker and his wife, and his will was revised.[14]

Just as Ray played a part in the library's creation in 1894, one can also say that the Walker Memorial Library returned the favor in 1998. Through the effort of a library employee, Ray's greatest community work—his extensive historical research—finally came together as a book.

For anyone interested in Westbrook history or genealogy, *Fabius M. Ray's Story of Westbrook* is an essential read. Many local historians recognize this

book as the most accurate and complete documentation of early Westbrook. In addition to relying on traditional sources, such as letters, books and public records, Ray gathered much of his information from the eldest city residents of the time, allowing him access to firsthand accounts and anecdotes of early eighteenth- and nineteenth-century Westbrook.

At the time of Ray's death in 1915, most of the papers in this collection remained unpublished. According to his obituaries, he saw his extensive, detailed work as still incomplete. He realized that much more information had yet to be uncovered.

Although a few of Ray's local history articles did appear in the *Evening Express* and other Portland papers, the remaining carbon documents containing his writings remained for years in the Walker Library's special collections. Local history researchers utilized these important, but reportedly hard to read, documents over the years. Finally, in the 1990s, Karen Sherman Ketover, a past librarian and curator at the Walker Library, took it upon herself to retype and assemble Ray's research documents into one interesting and informative book. This text, *Fabius M. Ray's Story of Westbrook*, is available for checkout to the community at the library, and reference copies are held both in the library's local history room and in the Westbrook Historical Society archives. One can even find it for sale on various Internet book sites.

Although Ray's hand in the establishment of Westbrook's municipal library and records of the city's early history were arguably his most long-lasting contributions to the city, he was also involved in his community in a number of other important ways.

Born in Windham in 1837, Ray undoubtedly came from an educated, or unusual, family, as he was named after a family of politicians and soldiers from ancient Rome. Ray graduated from Bowdoin College in 1861, and after a few years abroad studying French and German in Geneva and Heidelberg, he attended divinity school in Massachusetts. Although he graduated, he was never ordained. Instead, he settled in the Saccarappa area of Westbrook and married Mary Marrett, a local music teacher. While studying for his law exams and then establishing his legal practice in Saccarappa, Ray taught at the local school and tutored privately in languages and classical studies.

At the age of thirty-four, Ray was elected as a Westbrook representative to the legislature. Completing two terms in this position, he eventually served an additional term in the state senate as a senator for Cumberland County.

In the mid-1870s, his wife died, leaving him a widower with two young children, Willie and Mary.

In 1883, Ray remarried the much younger Josephine Belle Tibbetts—a reporter and historian known by most as Isabel—and took the post of judge for the Westbrook Municipal Court until 1885.

In addition to being recognized as one of the best-educated and well-read lawyers in the state, Ray was also known for his thoughtful, original and complex poetry. He published his first book of verse, *The Christmas Tree and Other Poems* (Dresser, McLellan and Co. of Portland), a collection of German translations, in 1874. His second book of poetry, *Translations, Imitations, and a Few Originals* (Smith and Sale of Portland), was published in 1904.

Years later, Ray was asked to write a commemorative poem to be presented at his fiftieth reunion at Bowdoin College, reportedly an honor that Ray treasured deeply. He penned this wistful and powerful reflection on aging and change for the occasion:

> *We're half way through. So sang our odist when*
> *The years gone by, like those to come, were twain,*
> *And chose the happy phrase as fit refrain*
> *To tell of years that ne'er should come again.*
> *Since then we've more than halved the century;*
> *But what of that? There's still no dearth of time,*
> *Nor will be while the patient aeons climb*
> *Toward the top round of eternity.*
> *Nay, what of that or this? A hundred years*
> *It will be all the same to you and me,*
> *Whether we pledge the passing century*
> *In aqua pure or the cup that cheers;*
> *For years will go, and lives will multiply,*
> *With earth below and overhead the sky.*

In addition to his work with verse, Ray edited a manuscript for publication in 1881 that reflected his deep interest in history. He compiled the writings of Dr. Caleb Rea, an ancestor who provided medical aid during the Ticonderoga Expedition of 1758 (Salem, Massachusetts).

Interested historians and writers can learn from Ray by browsing copies of his books, several other small titles and numerous scrapbooks and Westbrook records in the stacks and special collections of the Maine Historical Society.

Ray realized the importance of community libraries and of documenting and passing on local history to future generations. He was a teacher, judge, writer, politician and researcher looking to serve the good of his city.

Like many who have spent time talking to elder city residents or visiting a library's local history room or the community historical society, Ray also knew that, if one looks hard enough, there is always another interesting historical fact or story to be found.

City Celebrates
Warp Mill Founder

Woodbury K. Dana (1840–1924)

O n June 8, 1916, the millworkers of Westbrook were sent home early. At 4:30 that afternoon, they joined the rest of the city for a grand celebration that included two parades, a band concert and a reception complete with speeches, poetry and performances. The city was celebrating the fiftieth anniversary of the founding of the Dana Warp Mills, as well as the seventy-sixth birthday of the company's founder, Woodbury Dana.

Dana was one of the city's most respected citizens, a man who had overcome much to reach his positions in both business and politics. Despite being born with both auditory and visual impairments, with early teachers assuming that he had mental disabilities because of his poor speech, he made his family proud not only by completing school but also by serving his country in the Civil War and eventually building one of the most successful businesses in the city of Westbrook.

Woodbury Kidder Dana was born in his family's State Street home in Portland on June 7, 1840, the son of Louise (Kidder) of Hallowell and Luther Dana, a successful shipping merchant from Natick, Massachusetts. According to his biography, as a child, his poor vision and hearing led many to deem him unable to achieve in a typical educational setting.[15] His mother, however, stood by her son and eventually found a teacher who recognized

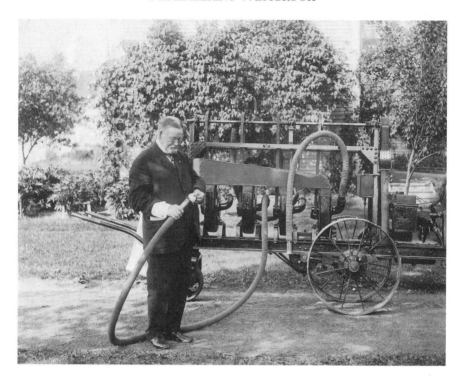

Woodbury Kidder Dana, circa 1900, with a cotton harvester of his own invention. *Courtesy of the Westbrook Historical Society.*

that his physical disabilities were the cause of his issues in learning and that, once those were administered to, the boy was sure to go far.

Never forgetting that teacher who believed in him, Dana attended Portland schools with his seven siblings, making a name for himself as a boy who stood up for what he believed in. He then went on to high school at Lewiston Falls Academy (now Edward Little High School), from which he graduated in about 1857.

Rather than pursue college or travel, as many of his social class might do upon completion of school, Dana—while still in his teens—plunged into the world of business. After some review of the market, he determined that good prospects lay in the manufacture of cod line, a special eighteen-thread fishing line that was in high demand at his family's store. With the support of his elder brother John, he leased a facility in Gray and began production of line, woven bags and yarn.

Although Dana learned a great deal about the manufacturing industry while running the plant, he soon realized that the business was too much for him to handle. He lacked experience in both manufacturing and management and soon was forced to give up the company, taking a small financial loss.[16]

He returned home, disappointed yet determined, and decided to head to Lewiston to study the mill business from the bottom up. His first position was as an assistant in the Lincoln Cotton Mill, where he worked twelve hours a day in any job for which he was needed. He then took work at three other Lewiston mills, learning all aspects of the business from machine work to management, earning only the most modest salary ($1.25 per day) but absorbing everything he would need to someday run his own successful mill.

In addition to his daywork, Dana spent many of his free evening hours tutoring fellow millworkers who had not had the benefit of an education. He purchased materials and books, later renting a small studio that he would use for his lessons, and gave several dozen men and boys instruction in math and reading. A religious man who saw value in sharing these skills with those who worked beside him, Dana took no payment for his teaching.[17]

In 1861, when Dana was a young man of twenty, tensions between the country's proslavery and antislavery factions were at a high. Abraham Lincoln had been elected president, and the South formally seceded from the Union. In 1862, several months after the First Battle of Bull Run, Lincoln formally announced a war order against the Confederate states. The Civil War had begun.

Thus, in August 1863, Dana left his position in Lewiston and, despite any difficulties he might have had with his vision and hearing, enlisted in the army. The following month, he began training in Augusta's Camp Keyes and was mustered into service in November of that same year. He joined Company K of the Twenty-ninth Maine Veteran Regiment.

By 1864, Dana found himself firmly entrenched in the war in the South. One of his first major confrontations in the war was the Battle of Sabine Cross in Louisiana, in which a full regiment of Ohio soldiers was taken prisoner before the arrival of the units from Maine and other states. In the fall of the same year, Dana and the Twenty-ninth Regiment fought in Virginia's Battle of Cedar Creek, which, after much hard fighting and many losses on both sides, ended as a major Union victory that helped cement Lincoln's reelection.

Conditions for the troops of the Civil War were dismal. In addition to facing close combat in the many violent battles, soldiers frequently found themselves without food and adequate shelter. Many froze to death in winter encampment sites or died from diseases brought on by malnutrition and the unsanitary surroundings. Troops, including Dana, were forced to write home to request simple items like soap and canned goods to supplement meager rations.

At the end of the war in 1865, Dana was reassigned for several months to Savannah, Georgia, during the Reconstruction. Although the situation was certainly better than his days on the battlefield, there was still much to be desired. "Rations were poor, the heat intolerable, flies and fleas a constant annoyance, and the Southern people none too friendly," Dana later wrote of his time there.[18]

Dana was honorably discharged in August 1865 and returned to Maine. Allowing himself little time to heal from the trauma of war, he threw himself back into work. Deciding he was ready to try again at running a business, he soon established a warp mill in Westbrook in partnership with Thomas McEwan at the site of the "old Westbrook Duck Mill," a denim and canvas manufacturing facility once located on Bridge Street overlooking the Presumpscot.

Dana's new mill had 720 spindles, which he used for manufacturing special fiber yarns for the weaving of blankets. McEwan released his share of the business early on, however, and in 1868, Dana was faced with a pricing downturn that could have proved devastating. Cotton and yarn prices that had been inflated during the Civil War years began to fall rapidly. Dana, however, possessing valuable knowledge from his years in the Lewiston mills, was able to ride out the slump that caused many similar mills to close.

Production grew quickly as Dana's firm became known around the country for its quality goods. The company continued to expand, moving to a Main Street facility in 1872 and, in 1880, to a wooden mill building once situated on the island on the far side of Saccarappa Falls. Despite a fire in the mill in 1893 and the great Westbrook flood of 1896, Dana's business continued to grow.

Dana was eventually joined at the mill by two of the seven children born to him and his wife Mary (Pickard) of Auburn, whom he had met during his days in Lewiston. After completing their educations at Westbrook schools and Bowdoin College, Dana's sons Luther and Phillip entered the business

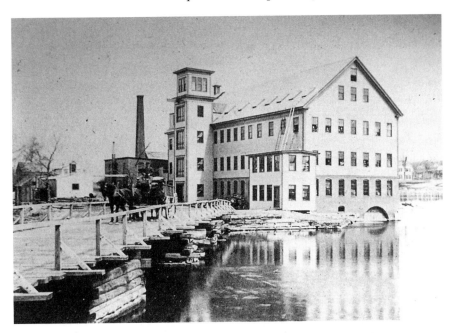

Dana's third mill building (acquired in 1880) stood on the island just over Saccarappa Falls. Photo circa 1885. *Courtesy of Michael Sanphy.*

Dana's mill expanded into its present location in 1900 and was connected to the island mill via a bridge. Photo circa 1920? *Courtesy of Michael Sanphy.*

then called W.K. Dana & Company. The firm grew several more times over the years until, by 1916, the facilities had increased from 720 spindles to over 35,000 and employed more than four hundred people, close to five percent of Westbrook's population.

Dana was known among these workers as a fair and generous employer. Perhaps due to his religious upbringing or his own long days of hard work in Lewiston, he prescribed to a similar philosophy of business as his Westbrook predecessor, S.D. Warren: employees worked best and showed most loyalty to a company when treated well.

This benevolent spirit extended beyond the walls of the mill and into the general community. A member of city council and active in the local Republican Party, Dana played important roles in the construction of the Forest and Bridge Street schools and in bringing electric lighting and public sewer systems to the city of Westbrook. He was also one of the first residents elected trustee of the then new (Walker) Memorial Library and was made responsible for the administration of library funds and policy oversight.

By 1916, when the city of Westbrook celebrated Dana's seventy-sixth birthday, he was one of the city's most respected and admired citizens. On the day of the celebration, five hundred schoolchildren marched from the mills to Dana's Mechanic Street home. A military parade complete with

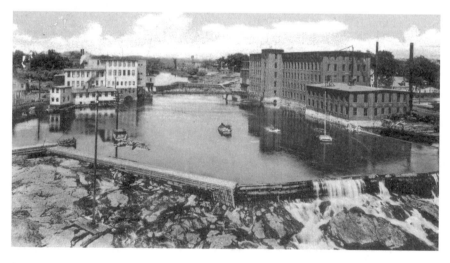

An early postcard of the Dana Warp Mills, dam and falls, circa 1910. *Courtesy of Michael Sanphy.*

Scottish pipers, marching band and the police and fire companies of the city followed. Townspeople honored him with songs and poems written for the occasion and speeches by important ministers, priests and other business owners.

The full-page newspaper article reporting news of the celebration summed up reasons for the mill town community's great admiration for Dana: "Not only…was [he] a soldier [who] fought in the Civil War, but…he was a self-made man and a successful business man, who had obtained his education in the college of hard knocks."[19]

Although the Dana Company ceased operation in the 1950s, the building still stands, filled with school programs, an acting studio, artists and many other local businesses, all a reminder of this man and all that he did for the people of Westbrook.

Former Prisoner of War Becomes One of Westbrook's Most Beloved Citizens

John E. Warren (1840–1915)

John E. Warren wasn't wearing his boots when he was captured by Confederate soldiers in Guntown, Mississippi, in June 1864. But he wasn't alone. The majority of the soldiers brought to the prison that became known as "the Bullpen" in Andersonville, Georgia, were without shoes. By the end of Warren's 162-day internment, most of his fellow inmates were dressed in rags, and all but a fortunate few remained without shelter from the scorching sun and the frigid night air. The land was swampy, the water contaminated and men packed in and dying all around him.

When a wound on Warren's foot became severely infected four months after his capture, he crawled his way with other ailing prisoners, most beyond help, to the camp sick yard. The infirmary was a series of tents set up just outside the stockade area of the main prison; it was understaffed with no anesthetics, insufficient amounts of medicine and limited equipment. Andersonville inmates feared the hospital—men who went in never came out—yet Warren took his chances, and it saved his life. It was here, after healing from his infection and gaining the ability to walk again with crutches, that a visiting officer selected him to join one of the few prisoner exchanges that took place at that point in the Civil War.

Warren was one of the fortunate. Andersonville, formally named Camp Sumter, was in operation from February 1864 to April 1865, and, in all, of the more than forty-five thousand Union soldiers held in the largest prisoner of war camp in the Confederacy, almost thirteen thousand perished of disease, malnutrition, violence, exposure to the elements and untreated injuries. By November 1864, one in every three prisoners had died there.[20] Of all the Union deaths in the Civil War, 40 percent of them occurred at Andersonville.

John Warren, upon his exchange after months of suffering in the infamous Georgia prison, would first buy himself a meal, take some time to let his foot heal and then go right back to fighting, remembering the men still languishing in the prison that had almost killed him. He rejoined Union troops and fought until the end of the war. Years later, after he had moved to Maine to take a position as a carpenter at his uncle's Westbrook paper mill, Warren wrote about his experiences. They would be published in the *Atlantic Monthly* almost a century later under the title of "Release from the Bull Pen." Known already as a hero of war, Warren would go on to become one of Westbrook's most respected and beloved citizens until his death at age seventy-five.

John E. Warren, circa 1900. *Courtesy of Michael Sanphy.*

Born in Grafton, Massachusetts, on October 6, 1840, John Ebenezer Warren was the son of Sarah (Potter) and Joseph A. Warren, the brother of the Westbrook paper manufacturer Samuel Dennis Warren. When John was still an infant, his family moved to Wauwatosa, Wisconsin, to take up farming in the wild and fertile territory that would gain statehood in 1848. Warren completed his schooling and was attending his first year of college in Madison when the preliminary skirmishes of the Civil War began at South Carolina's Fort Sumter.

The following month, at age twenty-one, Warren left college and enlisted with the Union army in May 1861. He initially served with the First Regiment Wisconsin Volunteers and then transferred to the Seventh Wisconsin Battery. By June 1, 1864, he was in Memphis under the command of Union general Samuel Sturgis, who was relatively new to the region. On June 10, troops from Warren's unit met Confederate soldiers under General Nathan Forrest, known as a gifted tactician, near an important section of the Mobile-Ohio Railroad line in Guntown, Mississippi. The stand and subsequent surge by the Confederate troops were strong, and Union lines were broken. Warren's regiment was forced to retreat.

It was during this retreat that Warren, who had removed his boots to give his sore feet some air, was captured and brought to Georgia. He was sickened by what he saw when he arrived at the Andersonville prison. He wrote:

> *Some had a mouthful of bacon which they were trying to sell or exchange for bread. The thought that we were expected to live with such a contemptible bit of meat served to us once a day did not seem at all funny at the time. The crowd about the gate was so dense that one could hardly find standing room, let alone a chance to sit upon the ground. Except for the street…the space was all taken up by little tents or shelters, mostly made of blankets, under which men cowered…[A]fter our rations were served, we lay down blanketless on the sodden, reeking earth and slept as best we could.*[21]

Warren soon found that violence was common among the prisoners, some of whom took to stealing and even murder to secure enough food to stay alive. "Almost every morning someone would be found with his throat cut," Warren wrote, "and I have seen men knocked down and robbed in broad daylight, with hundreds looking on not daring to assert themselves against the banded violence of the raiders, as they were called."[22]

In addition to such treatment by fellow prisoners, inmates faced the daily risk of being shot by guards for getting too close to the prison boundary. If an inmate was not murdered, death by starvation, gangrene from untreated wounds and diseases of malnutrition such as scurvy and dropsy (limb swelling, or edema) were common and unstoppable.

There was simply not enough food or funds to care for the more than forty-five thousand prisoners who passed through the gates at Andersonville. The Confederacy was poor and barely had enough food to feed its own troops, let alone the prisoners. Prison officials did their best to provide some sustenance, albeit mostly corn bread or mush and small scraps of bacon or beef when available. Sadly, it was Union commanders who ceased prisoner exchanges early on in the war, knowing well the fate of soldiers left to suffer in the Southern prisons.

Warren was one of the few sent for exchange in the winter of 1864. He was conveyed to Savannah and on to Union lines at Annapolis; many of his fellow exchanged died en route to salvation. Upon reaching the Naval Academy in Maryland, Warren was paid $0.25 for each day of his imprisonment, totaling about $40.00 (equivalent to about $550.00 today). He treated himself that evening to a sizeable dinner, complete with the vegetables, clean water and fresh meat that he had gone without for so long. Within a month, he was back on the fronts, where he remained until the very end of the Civil War in July 1865.

Shortly after his honorable discharge from the army, he came to Westbrook to join the ranks at the S.D. Warren Company—then known as the largest manufacturer of paper for books and magazines in the world. Warren entered the business as a carpenter despite his connections that could have admitted him to a far higher position. He spent the next twenty years working his way up, learning the business the old-fashioned way: through experience. He became resident agent of the mill in 1884, building himself a fine house on Cumberland Street that has since been known as the John E. Warren House (although it was moved to the nearby Cottage Place in the 1980s).

Warren was a first-rate manager, running the business with skill and, in the Warren way, always looking out for the benefit of his employees. "Many families in the Paper City still have Mr. Warren to thank for their success, happiness, and even for generous financial assistance in times of stress," read his front-page obituary.[23]

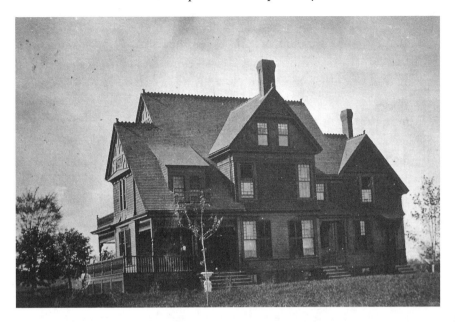

The John E. Warren house (built 1882) once stood on Cumberland Street near the large brick mill manager's house. The home was moved to its present location on Cottage Place in the 1980s. *Courtesy of Michael Sanphy.*

In addition to his duties at the mill, Warren was very involved in community affairs. He was elected to the Maine House of Representatives in 1873 and, when Westbrook gained cityhood in 1891, became a member of the first city council. He went on to serve for a number of years, eventually becoming president. He, along with fellow businessman Woodbury Dana of the Dana Warp Mills, was selected one of the first trustees of the city's new Walker Memorial Library. Warren later served as a member of the Maine State Senate in 1909.

Warren and his wife, Hattie (Brown) of Wauwatosa, Wisconsin, had four children, three of whom survived past childhood and completed their schooling in Westbrook. One son, Joseph, followed in his father's footsteps at the mill and worked his way up to the position of plant manager by 1907. He then took on the role of vice-president and, later, was put in charge of the Warren research laboratory.

John Warren achieved much after surviving over five months in one of the worst prisoner of war camps on U.S. soil. Fellow prisoner John L. Ransom wrote in his diary in July 1864, just one month after Warren's

arrival: "Here we have the worst kind of water...And for air to breath, it is what arises from this foul place. On all four sides of us are high walls and tall trees, and there is apparently no wind or breeze to blow away the stench, and we are obliged to breathe and live in it...I keep thinking our situation can get no worse, but it does get worse every day and not less than 160 die each twenty-four hours."[24]

Along with the other survivors of Andersonville, Warren, until his death on August 13, 1915, surely never erased the scars of war or the reminders of the thirteen thousand fellow soldiers who died during those days of torment in "the Bull Pen."

City Home to Early Baseball Superstar

George F. Gore (1857–1933)

S outhern Maine baseball fans know the name of Bill Swift, the 1984 Olympic team pitcher from South Portland. They have probably also heard of Bob Stanley of Portland, the 1980s first-round draft pick and relief pitcher for the Boston Red Sox.

Most don't realize that Westbrook, too, had some Major Leaguers, the first of whom was a hard-hitting country boy who reportedly showed up to his professional tryouts without shoes. George F. Gore, who began his career as a member of the S.D. Warren Company team,[25] eventually played for fourteen seasons in the Major Leagues. During his career, he won a National League batting title (and has been the only Mainer to ever do so), set three Major League records and had an overall career batting average worthy of the Hall of Fame: .301.

Although the *Baseball Encyclopedia* tells us that Gore was born on May 3, 1857, in Westbrook (then Saccarappa), his obituary and several other sources state that he was actually born in Hartland (located between Bangor and Skowhegan) about 1854. In either case, census records indicate that Gore was living in Westbrook by the age of three. His father, a day laborer of limited means who spelled his surname as both "Gore" and "Gower," moved the family of seven into a neighborhood filled with mill operators, dyers

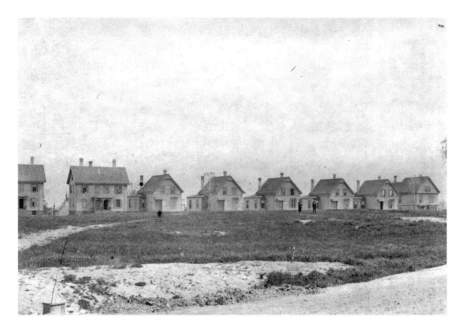

George Gore grew up in an area much like Scotch Hill, an area of Westbrook (today's Walker Street) once populated by day laborers and skilled millworkers alike, many of whom were Scottish immigrants. Photo late 1800s. *Courtesy of the Westbrook Historical Society, Warren Memorial Library Photographic Collection.*

and other laborers and manufacturing workers. This was an area much like Westbrook's working-class "Scotch Hill," where reportedly baseball was the most popular neighborhood pastime as far back as the mid-1800s.

Gore showed great baseball ability at an early age and, by the mid-1870s, was playing with the S.D. Warren/Westbrook team called the Westbrook Resolutes. Credited by a Westbrook teammate with "nine-position perfection,"[26] Gore was soon invited to join the larger Portland Club to replace a less-than-perfect catcher.

Although professional baseball was still relatively new (the first pro category had been established in 1869), Gore's powerful batting and adept fielding abilities soon brought him organizers' attention. After being spotted at a Portland exhibition game by veteran player and Massachusetts team manager Jim Mutrie, Gore was signed to join the Fall River, Massachusetts team (New England League)—presumably after his barefoot tryout—in 1877. He was initially paid $15 a week, equivalent to about $342 today, good money for a man of such modest background.[27]

In 1878, Gore joined the New Bedford Whalers and, with a .324 batting average, helped lead the team to a New England League championship.[28] Scouts from the newly established National League were impressed. Gore was soon signed to the Chicago White Stockings (now the Chicago Cubs) in 1879 after earning what is now history's title as "baseball's first holdout."

The White Stockings owner, A.G. Spaulding, offered Gore $1,200 to sign, but—according to accounts—the skilled and confident Gore wanted $2,500. Spaulding traveled to Boston in person to compromise, and the agreed-upon figure was $1,900, equal today to about $43,000.

Gore made sure Spaulding would have no regrets. The following year, 1880, Gore won the National League batting championship with a .360 average and helped lead Chicago to five titles in his subsequent seven seasons.

These feats occurred at a time when the rules in baseball were very different from today. For example, bat lengths had not yet been standardized, and players caught mostly barehanded until the mid-1890s. In addition, games were often dominated by pitchers, who stood ten to fifteen feet closer to a hitter than today and were permitted to pitch both underhand and overhand. They were also allowed to run several steps before a pitch and, until 1881, were not fined for hitting the batter.[29]

All in all, catching required a particular toughness, and runs were hard to come by: the overall National League batting average of 1880 was a low .245.

In his early years with Chicago, Gore played a variety of positions, including first and third bases, but eventually settled in center field. It was while playing this position that he set a Major League record of five assists in one game. Also while with Chicago, Gore established the MLB record for seven steals in a sole game, a record that has since been tied but not yet beaten. In 1885, he set a third record for the number of extra base hits in one game (two doubles and three triples), which also remains unbeaten but was tied most recently in the summer of 2008.

Gore wasn't just an exceptional hitter and catcher; he also had a good eye. Gore led the league in the 1886 season with one hundred bases on balls. This statistic is particularly astounding when one considers that it then took nine balls instead of four to make a walk.

Sadly, while Gore's career flourished, he was experiencing turmoil in his personal life. He had married young to Angie Case of Westbrook in 1874,

but despite the fact that he lived in Maine between baseball seasons early in his career, the couple lived separately. The 1880 summer census records place them both in Westbrook, but Gore listed himself as "single" and his wife listed herself—with some clear bitterness—as "widowed." In addition to his unhappy marital life, Gore had issues with alcoholism that began to impede his career. He reportedly began to have problems with Chicago team captain and manager Cap Anson. In 1885, he was suspended from the World Series for drinking.

The following year, he was traded to the New York Giants (which became the San Francisco Giants). By no coincidence, this team had been co-founded by his previous Fall River manager and discoverer, Jim Mutrie. Gore left Chicago with some resentment but dedicated himself to his new team, helping them take their first two championships in 1888 and 1889. He played with the Giants until 1892, despite some team problems and financial troubles in 1890 that put his National League career briefly on hold.

In New York, Gore met and moved in with the recently divorced Florence "Florilla" Sinclair and was eventually granted an official divorce from his first wife Angie. Angie, according to public records, had somehow already remarried in the early 1880s in Westbrook so was presumably happy to bring her marriage with Gore to a documented close in 1894.

Gore remained with Sinclair after being traded to the St. Louis Browns, with whom he played and managed for only one season. Former teammate Anson later wrote of Gore, "He was an all-around ball player of first class… and had it not been for his bad habits he might have still been playing ball today. Women and wine brought about his downfall."

Despite his rough habits, Gore lived until old age, passing away in 1933 after living for thirteen years in Nutley, New Jersey, working for the railroad.

Gore granted several newspaper interviews later in life and spoke of how, upon his occasional return to his boyhood town, he was pleasantly surprised to be recognized as "the Westbrook boy who made it to the Major Leagues."[30]

Philanthropist, Novelist and Advocate of Women, Youth and Immigrants

Cornelia L. Warren (1857–1921)

Isometimes try to imagine what life might have been like for my great-grandparents in the early 1900s. From their home on Portland's Deer Street, they spent their days surrounded by Italian *bottegas*, butchers, laundries—pleasant reminders of their homeland. But it was a homeland to which they would never return. Although they loved their new country and the opportunities the United States provided them and their children, it couldn't have been an easy life, especially at first. Not speaking English and unfamiliar with American culture, their struggle to acclimate would have endured for years.

Had they settled in Boston instead of heading north to Maine, they would have faced the same challenges. However, they might have found some initial assistance through Denison House, a settlement home started by a group of upper-class, well-educated women who saw a need to improve conditions in Boston for newly arrived immigrants. The main intent of Denison House was to create a home in which educated women shared a residence with often impoverished new immigrants, acting as educators, companions and social workers.[31] Forward-thinking philanthropists like Cornelia Warren invested time and money in Denison House in order to provide educational opportunities, temporary housing, a place for

community organizations and recreation for the mostly Greek, Italian and Syrian immigrants of Boston from 1892 through 1942, at which time the home was relocated to Dorchester.[32]

Although most Westbrook residents might never have heard of Denison House, they are quite familiar with the name of Cornelia Warren. From the city's outdoor pool to the skating rink on Lincoln Street to the Cornelia Warren Field, her name greets inhabitants from the signage of many of the city's best recreational facilities.

Cornelia Lyman Warren was born on March 21, 1857, in Waltham, Massachusetts, the daughter of Susan (Clark) and Samuel Dennis Warren, the founder of Westbrook's S.D. Warren Company. Theirs was undeniably a family of great means, but Cornelia's religious and progressive parents raised her to believe that wealth was nothing if not used to help others.

Although Warren attended the best private schools in Boston and had graduated by the age of sixteen, she decided that a higher education was not her destiny. Instead, she broadened her knowledge privately with the help of Harvard and MIT tutors. She was fluent in French and maintained her

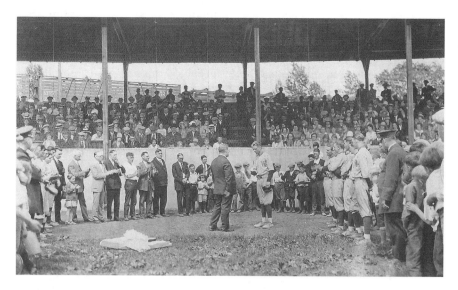

Once a favorite community gathering ground, the Warren Field, circa 1925, was one of the facilities made possible by the Cornelia Warren Community Association. In its prime, the field included stadium seating and locker rooms. *Courtesy of the Westbrook Historical Society.*

studies in a number of academic areas, including music and her preferred subject, philosophy.

Having traveled throughout Europe, Japan and Egypt with her father by the time she was a young adult, she later continued her trips abroad with her mother on many of her art-collecting excursions. The family homes were filled with the finest treasures, including a prized Filippino Lippi *Holy Family* from the Italian High Renaissance. Like her mother, the younger Warren had a good eye for art and antiquities.

Warren also held a deep interest in literature. She penned many unpublished poems as well as a novel, *Miss Wilton* (Houghton Mifflin, 1892), and a self-published tribute to Susan Clark Warren titled *A Memorial of My Mother* (1908). In addition to her own literary pursuits, she assisted in the management of the Warren Reading Room at the Westbrook paper mill after the death of her parents to ensure that the company's workers would continue to have access to quality reading material. Until her death, she was a trustee of the endowment (Warren Memorial Trust Fund) left by her mother for the maintaining of the library and for other artistic and educational programs to benefit the Westbrook community.

A bright, independent woman, Warren also—like her father—had a keen sense of business. When she inherited her family's Cedar Hill estate in Waltham in 1888, she began a farm and dairy establishment using the latest sanitary techniques (before homogenization and pasteurization became common practice) to provide the healthiest, purest milk to her customers.[33] Warren was a proponent of sustainable agriculture, which focuses on proper use of the environment, the use of local products and labor and economic equity for farmers. And on her farm, she ensured that her practices matched her philosophy.

In addition to using her estate for her business enterprises, she also enjoyed opening the grounds to local groups and organizations for picnics and other gatherings. The trails and woods were made available, and she even had a bowling alley built into the upper floor of her carriage house.[34] In a move deemed eccentric by some in her family, she also had an elaborate hedge maze, which included 1,800 feet of pathway, constructed on the property in 1896 for the pleasure of her guests.

Warren's benevolence extended far beyond the reaches of Waltham, both within the United States and abroad. A longtime trustee of both Wellesley

College and Bradford Academy—a private school once located near Haverhill, Massachusetts—she was also extremely generous in her gifts to a number of Congregational missions and to an international girls' school in Spain.

Although she never lived in Westbrook, she was a frequent visitor and did a great deal for this small manufacturing community as well. An advocate of women's rights, Warren made sure that her gifts would be enjoyed by adults and youth of both genders. In 1903, Warren financed the remodeling of a dance and banquet hall in the Queen Anne–style Warren Block located at the intersection of Main and Cumberland Streets. The third floor was turned into a basketball court, complete with lockers and dressing rooms, and both boys' and girls' teams were organized there.[35]

Warren also provided equipment to the Warren Manual Training School (once housed in the brick building on the corner of Main Street and the Westbrook Arterial), insisting that all youth should be able to learn

The Warren Manual Training School (or Warren Sloyd School) (1895), generously supported by Cornelia Warren, was a place where students of both genders could learn trade skills. *Courtesy of the Westbrook Historical Society, Warren Memorial Library Photographic Collection.*

a trade there. While first opened to girls only, eventually students of both genders were taught the various disciplines, from cooking and sewing to woodworking.[36] Each pupil was required to complete a manual project before the completion of the eighth grade, and some examples of this fine handiwork still exist in homes in Westbrook today.

A great advocate of fresh air and physical activity, Warren also financed for the construction of Westbrook's tennis courts and the "old swimming tank" that once enclosed a small section of the Presumpscot. Complete with observation deck, slide and plank walls to filter the flowing river water, the tank provided several decades' worth of amusement for Westbrook youth.

Warren spent her life giving, and those contributions did not conclude with her death. When she passed away in June 1921, among her bequests were almost $10,000 in funds for various ministries and church educational outreaches, another $10,000 divided between the Waltham Hospital and the Boston Museum of Fine Arts and thousands more spread among forest preservation organizations, schools and colleges and foreign settlement

The construction of the "old swimming tank," built over the Presumpscot River in the early 1900s, was funded by Cornelia Warren. The tank was torn down in 1947, when the public became more aware of the polluted state of the river. *Courtesy of the Westbrook Historical Society, John Hay Collection.*

The concrete supports in the Presumpscot River are all that remain of the swimming tank that entertained Westbrook youth for several decades. *Courtesy of Michael Sanphy.*

missions such as Denison House.[37] Seventy-six acres of her Cedar Hill Estate were also gifted to the Girl Scouts of Massachusetts, land that they use to this day for camping, trekking and other Girl Scout functions.

To Westbrook, she gifted $100,000 in cash (equivalent to over $1 million today) and over $25,000 worth of property for educational and recreational purposes to benefit the community. In 1925, the Cornelia Warren Community Association was formed to oversee the trust and has since contributed toward the construction of many of Westbrook's parks and fields, as well as to supplying equipment for those facilities.

Cornelia Warren never married or had children of her own, but she ensured that her legacy would live on to benefit generations to come, from Boston immigrant families to Waltham ball players and the Massachusetts Girl Scouts to the very grateful people of Westbrook, Maine.

The Man Behind the Building: Businessman, Legislator, Reformer

John Clark Scates (1859–1949)

One of the most noted casualties of Westbrook's urban renewal was the beautiful brick Scates Block at 868 Main Street. For almost eighty years, until its much-contested destruction in 1981, the elegant structure stood at the intersection of Main and Bridge Streets overlooking what would become Rudy Vallee Square.

Although most longtime residents remember the Scates Block, only among the most learned state political historians is John Clark Scates, the man behind the building, well known for his great success in business and an impressive political career that spanned more than fifty years.

Scates was born on a farm in Randolph, New Hampshire, on January 21, 1859, the son of Joseph Smith Scates and British immigrant Margaret Boothman Scates. According to biographies, Scates's father and grandfather were both strict adherents to the Jeffersonian principles of liberal democracy.[38] The idea of representative politics for the people and by the people, it seems, was in the family genes. Between his father and two uncles, James Jr. and Ithiel Scates, the combined years of service as selectmen to the city of Randolph reached almost three decades.

Scates's father, however, did not live long enough to see his son follow him into politics. He died at the age of thirty-seven. At just eight years old, the

John Clark Scates at home with his granddaughter Marguerite, circa 1940. *Courtesy of Michael Sanphy.*

young Scates left Randolph with his mother and younger brother, relocating to Bridgeton, Maine, where Mrs. Scates soon remarried to fellow British immigrant Joseph Dufton.

One year later, the family moved to Lisbon Falls, where Scates and his brother completed their schooling, and Dufton entered into the drug business. Both boys apprenticed with their stepfather and became apothecaries soon after graduation. Scates married Ada Lewis, also of Lisbon Falls, and transferred to Westbrook in the early 1880s to open his own drugstore—Scates & Co.— at 74 Main Street, while his brother Eben relocated to Fort Fairfield to do the same.[39]

In 1889, Scates expanded his business interests and worked with a partner, most likely his brother-in-law Thomas M. Lewis, to form the Lewis & Company firm in Boston. By the mid-1900s, Lewis & Company had become the sixth largest drug company in the country.

Scates held additional interests in lumbering, forming with his brother the Scates Lumber Company in Aroostook County.[40] Along with a number of

other prominent Westbrook figures, he also worked toward the establishment of the Westbrook Trust Company, which, after a series of mergers over the past century, has since become part of the Bank of America.

Almost as soon as he reached adulthood and came to Westbrook, Scates entered town politics, serving first as town clerk in the 1880s and then as alderman on the town council in the 1890s. His work on financial and planning committees impressed the state Democratic Party, and he was selected as delegate to attend the Democratic National Convention in Kansas City in 1900.

It was in 1903 that Scates, seeing a need for a suitable home for the post office and town municipal services, commissioned construction of the Scates Block. The building housed elegant fixtures, including marble staircases and etched hanging lighting. In addition to the postal service and town offices, it became home to the Masonic Hall, a bowling alley in the basement and, of course, the Scates & Company pharmacy.

As his drug businesses grew, Scates's political career continued to develop. He was chosen as chairman to the Democratic Committee for Cumberland County in 1906 and elected to the state legislature the following year. According to newspapers of the time, "He was soon appointed member

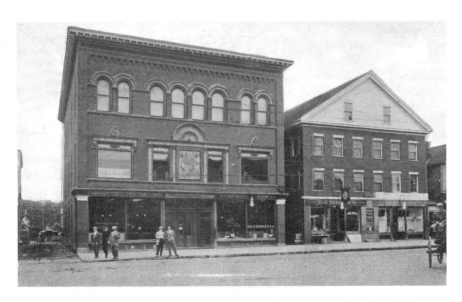

The Scates Block, built in 1903, once stood on Main Street at the site of today's CVS pharmacy. Photo early 1900s. *Courtesy of Michael Sanphy.*

of a committee on appropriations and financial affairs, where his sound judgment and business ability were at once recognized."[41]

And he lost no time in getting to work on reform. He saw a desperate need for stricter oversight to government spending and immediately penned the legislation that would create a state auditor, an elected body in charge of overseeing all state government accounts. Scates pushed hard for the approval of this bill with persuasive speeches and diplomatic networking and is credited with its success—and thus with the creation of the State Auditor Department, which has been responsible for monitoring state spending accounts for more than one hundred years.[42]

While in office, he teamed his keen business sense with his liberal political persuasion to work for infrastructure improvements to the state that included bonds for road development throughout Maine. One such piece of legislation called for the first gas tax, to be used for much-needed road repair and construction. We certainly cannot blame him, however, for today's high fuel prices: he also fought against raising the tax—from four to five cents—in 1920.

FOR CONGRESS

JOHN CLARK SCATES

Scates's campaign poster for U.S. Congress in 1908. *Courtesy of the Westbrook Historical Society.*

Although Scates was later unsuccessful in his campaign for U.S. Congress, he lost the election by only three hundred votes. In total, Scates served six terms on the state legislature up through 1936 and one term (1915–16) on the Governor's Council.

Over the years, Scates was involved in numerous other profitable businesses, but, in keeping with his political philosophy, always with a goal of improving his community. He was one of the founding incorporators of the Windham and Harrison Street Railroad Company, which brought the first electric street cars to Westbrook and Windham. This line later became part of the Portland Railroad Company.

He was also one of the founders of the Mallison Power Company, which allowed the city of Westbrook access to the electrical power it needed to develop its industries, including expansions in the Dana Warp Mill and Haskell Silk Mill. This corporation eventually merged into Central Maine Power.

Later, during the Great Depression, Scates put his financial knowledge to even more significant use. In 1929, the country was hit by the Black Tuesday market crash. Banks around the country, including the Westbrook Trust Company—by then the main bank of the people of Westbrook—went into crisis. Americans were in a panic and rushing to withdraw their savings; as a result, by early 1933, many banks had crumbled, closing their doors for good.

A trolley car from the Westbrook, North Windham line. Scates was one of the founding incorporators of the Windham and Harrison Street Railroad Company, which brought the first electric streetcars to Westbrook and Windham. *Courtesy of Michael Sanphy.*

To prevent further damage, the newly inaugurated President Roosevelt declared a nationwide bank holiday—forcing all banks to close their doors until the Emergency Banking Act of March 1933 was passed and the public's confidence regained. As soon as the bank holiday came to a close, Scates put all of his efforts toward reorganizing and stabilizing the Westbrook bank. He later became president of the company, where he served until his retirement in 1940.

Despite his wealth and great success in business, he held true to his Jeffersonian ideals and was even quoted in an interview later in life as remarking that "something must be done…to stop the concentration of wealth in the hands of a few, or the fate of the Republic is doomed."[43]

Scates remained in Westbrook, throwing annual garden parties and raising his two children, Ruth and Karl, and several grandchildren in his Brackett Street home. He died after a long illness on May 10, 1949.

Inventor's Career Began with Broken Window

Howard Parker (1863–1950)

H oward Parker, an inventor once called "the Thomas Edison of the pulp and paper industry,"[44] got his professional start in the city of Westbrook—courtesy of a badly aimed snowball.

One of seven siblings, Parker was born in Westbrook's neighboring town of Gorham on April 17, 1863, the son of Ellin A. and merchant Jeremiah Parker. Although Parker attended some school, by age seventeen he had begun to work at a local pulp mill, an industry in which he would remain, with great success, until his retirement. At the age of twenty-three, already showing skill and interest in the workings of mill technology, Parker transferred to Westbrook for an apprenticeship with a Main Street machinery company.

It was here, before work one day, that he gathered up a ball of wet snow and let it fly at a teasing co-worker. Instead of hitting his target, however, his icy projectile crashed through the window of a nearby underwear manufacturing shop run by a man named Keeler.[45] According to a newspaper interview years later, a white-faced Parker confessed his wrongdoing to the irate shop owner. Although he earned only sixty cents per day—and spent most of that on boarding—he offered to work until he had paid for the damage.

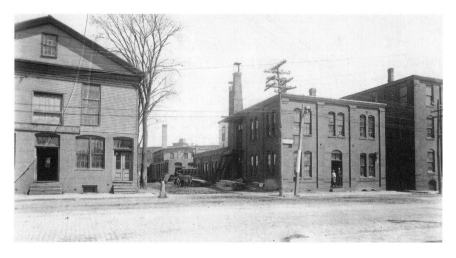

Parker's first machinery-related position was at the Foster and Brown Machine shop (at center). *Courtesy of the Westbrook Historical Society, John Hay Collection.*

Parker was sure that he had reached the end of his very brief career when he later heard Keeler's voice booming from the office of his employers, Thomas Foster and Nathaniel Brown. But he was in for a surprise.

Perhaps Keeler respected Parker's honest confession or had heard word of Parker's exceptional mechanical skills. Or perhaps the businessman just had some snowball fight memories of his own. Whatever the reason, he informed Foster and Brown that to repay the debt, Parker was to personally inspect and deliver every piece of machinery that Keeler ordered for his factory. Keeler added that he wanted Parker's pay increased by ten cents a day, with his manufacturing company to pay the difference.

On one of Parker's first deliveries, Keeler introduced the young man to the head mechanic of his shop, Leonard Quinby, a talented machinist and one-time band instrument maker. The elderly Quinby found an eager pupil in the curious and intelligent Parker. A close friendship developed, and it was in Quinby's home workshop that Parker completed his first invention: a machine for the manufacture of paper pails, containers similar to those now used for restaurant takeout. Parker got the patent—his first of many—in 1886.[46]

While spending time at Quinby's home, Parker also became acquainted with Nellie Day, Quinby's granddaughter. A romance began, and the pair married in Westbrook in January 1887. Sadly, Leonard Quinby died later that same year.

Shortly after his mentor's death, Parker found employment at the Fairbanks Scale Company in St. Johnsbury, Vermont. This turned out to be a satisfactory position indeed. According to the company's website, by 1897, it held 113 patents for improvements and inventions in weighing, produced eighty thousand scales annually and sold its products in China, Cuba and throughout Europe.[47]

Parker worked with the company for fifteen years, inventing and improving upon many machines for the manufacturing of paper and other pulp products. He stayed with the Fairbanks Company until the death of the founder and then opened machine shops first in Bellows Falls, Vermont, and then in Nashua, New Hampshire, where he continued to invent various paper and pulp processing devices.

Parker and his foster daughter, Gabrielle Thibeault. *Courtesy of the Berlin and Coos County (New Hampshire) Historical Society.*

In 1912, he joined hundreds of other scientists and technicians in Berlin, New Hampshire, in the Research and Development Department of the progressive Brown Company. There he invented and patented fiber conduit—and the machines to produce it. Fiber conduit was a bituminized pulp product that was used for conducting electrical wires and cables underground. It was sold throughout the country as cities shifted away from running electrical wire overhead to space-saving subterranean installments.

The Brown Company and its products became internationally known in the 1920s. A 1925 company bulletin speaks of two record-breaking shipments to Spain for 500,000 and 1,000,000 feet of conduit to upgrade the country's electrical systems.[48]

While with the Brown Company, Parker also developed a model for a pulp-based gunpowder keg. At the start of World War I, with the country in great need of new technology and equipment to meet the needs of the military, he presented his design to the War Department in Washington, D.C. He left the capital with a contract to produce eleven million of his fast-opening, sturdy kegs.[49]

At the time of a 1936 interview for a Portland newspaper, almost eight years after his retirement from the Brown Company, Parker held over 160 patents for his inventions. These detailed patents and machinery sketches today fill a Westbrook Historical Society binder as thick as many dictionaries.

Parker retired in 1929. He and his wife returned to Westbrook with their foster daughter, Gabrielle Thibeault, the daughter of a live-in assistant whom they had helped raised from infancy and had grown to adore. The family took up residence in Quinby's old house—where both Parker's wife and his first invention were born. Parker lived there until his death on May 13, 1950.

Nurse Didn't Shy from Horrors of World War I

Cora A. DeCormier (1887–1942)

In the list of the 390 Westbrook residents who signed on for duty in World War I, a woman's name stands out. At a time when women's involvement in the U.S. military was still very limited, Cora DeCormier found a way to enlist and serve as a nurse for four years in the Great War. By the war's end, DeCormier's outstanding bravery and service had been rewarded with five medals of honor and decoration by two European kings and the government of France.[50]

One of ten children, she was born in Westbrook in 1887 to French Canadian immigrants François and Regina (Tanguay) DeCormier. She was a parishioner of St. Hyacinth's Catholic Church and attended local schools—St. Hyacinth's School and Westbrook High School—up through graduation.

"She is a great promoter of new ideas, but owing to the slowness of the class of 1906, she has never been able to carry out any of them," reads an entry in her 1906 Westbrook High School yearbook. Her classmates must have caught an early glimpse of her potential.

After high school, DeCormier attended St. Mary's Nursing School in Lewiston, graduating in 1912 in a class of only four women. She then began work with tuberculosis patients throughout Maine, the South and the

Like many in Westbrook's once significant French-speaking community, DeCormier was a communicant at St. Hyacinth's Church (at left) and attended the church's parochial elementary school (at right). This wooden church was eventually torn down and the present-day stone church was constructed in the 1940s. *Courtesy of the Westbrook Historical Society, Walker Memorial Library Photographic Collection.*

Midwest. An adequate drug treatment for the disease would not be available until 1943, so the only treatment options were rest and fresh air, which were not always successful. DeCormier and other tuberculosis caregivers would have thus seen a great deal of suffering and death.

Upon return to Maine in about 1914, she was named nursing superintendent of Webber's Hospital, now the Southern Maine Medical Center, in Biddeford. By August of the same year, military skirmishes had broken out in Europe. Germany declared war on Russia and then pushed forward to invade France via Belgium.

An ally of France, Great Britain reacted by issuing an ultimatum for immediate withdrawal of German troops from their neutral European neighbor. When Germany rejected these demands, however, Great Britain had no choice but to declare war. This pulled Canada into the conflict as well, and the Valcartier military training camp just north of Quebec City drew the first Canadian volunteers.

Canada's first unit, the Canadian Expeditionary Force, arrived in England and was committed to battle by October 1914. The troops went to war in northern France the following February, their first battle being fought in the French village of Neuve-Chapelle.

Perhaps it was the pull of family patriotism—directed toward the Quebecois volunteer troops or her distant ancestors from Paris and Brittany—that motivated DeCormier into action. At the age of twenty-seven, DeCormier traveled to Montreal along with a number of other Westbrook volunteers who could not wait for the United States, still teetering on the edge of its isolationist policies, to declare war.

She completed her enlistment papers on March 22, 1915, lying about her birthplace—listing it as Canada instead of Maine—in order to join the military effort. The healthy five-foot, two-inch nurse with dark hair and eyes was approved for service with the Canadian Army Nursing Service on April 1.[51]

DeCormier arrived in Europe when conflict was at a high. Confrontations such as the devastating Ypres Salient in Belgium and the Battle of Marne in France were being fought on the Western Front. Fearsome losses on both sides resulted. The wounded were numerous, their injuries grave.

One physician with the Canadian army, Lieutenant Colonel John McCrae (the author of "In Flanders Fields," one of the most memorable war poems of the era), was in the midst of the horror. In his journal, he referred to the Battle of Ypres as seventeen days of Hades. "At the end of the first day if anyone had told us we had to spend seventeen days there, we would have folded our hands and said it could not have been done," he wrote.[52]

While treating war injuries has never been for the faint of heart, new military technologies and strategies presented additional challenges for medical personnel. Tanks, mines, flamethrowers and air attacks—all unknown before World War I—caused horrific injuries, often resulting in shattered and missing limbs and paralysis.

Tuberculosis, pneumonia, influenza and serious infections were also common, and antibiotics remained undiscovered until 1928, years after the war had ended. Soldiers died of tetanus, gangrene and other infection-related complications, and amputations were common. This war also introduced two other new classes of injuries that drew on the skills of the nurses: wounds from chemical warfare (chlorine and mustard gas were

now utilized in battle) and the often serious complications of shell shock or neurasthenia, understood today as post-traumatic stress disorder.

Thus the nurses, known as sisters and matrons, labored on, wanting for supplies, witnessing the horrors and never knowing if a day of work would bring three patients or three hundred.

In addition to her base hospital work, DeCormier tended to soldiers directly in the trenches. While performing her duties on the battlefield, she was once exposed to gas and injured. Although reports say she never completely recovered, she refused to give up her work.

DeCormier's great contributions were first officially recognized in 1917. King George V of England summoned her to Buckingham Palace along with five other nurses for a special wartime investiture ceremony in which she was decorated with the Royal Red Cross. Her later decorations included the Croix de Guerre medals of Belgium and France.

Even after the war, DeCormier continued to dedicate herself to the service of the community. She was put in charge of public health nursing in Southington, Connecticut, and became involved in studies of communicable illnesses and the vaccination of schoolchildren. She was also a charter member of the Canadian Legion here in Westbrook, formed by servicemen who, like her, enlisted in Canada before the United States entered the war.

Although the 1923 Westbrook community directory places her in New York, she eventually returned to Maine to serve as maternity ward superintendent of St. Mary's Hospital in Lewiston until she herself succumbed to illness. She died of a cerebral hemorrhage on March 27, 1942, at the age of fifty-four.

"Ginger" Fraser: Respected Soldier, Teacher, Coach

Paul F. Fraser (1892–1938)

Westbrook baseball players who gaze past home plate from the outfield of the shady Fraser Field behind the Cornelia Warren Pool may notice the small granite monument that reads:

> *Paul "Ginger" Fraser*
> *1892–1938*
> *Athlete Soldier Patriot*
> *Teacher Coach Mentor*
> *He was a man who believed that good*
> *Sportsmanship fosters good citizenship*

Although I don't play ball, I pass the stone often on cool summer walks along the Presumpscot path, and I've wondered about this man who inspired such admiration and respect.

Paul Frederick Fraser, later nicknamed Ginger, undoubtedly for his ruddy complexion, was born in Roxbury, Massachusetts, on November 15, 1892. He was one of six sons of Ada (Shanklin) and Robert Henry Fraser, a mechanical engineer. His sturdy build and natural athletic ability made him an early star in sports—especially football. Fraser made the team for

Paul "Ginger" Fraser played on Colby's varsity team from 1911 to 1914, leading the team as captain during his final two years at school. *Courtesy of Janet Fraser Mitchell.*

Boston Latin School at age thirteen and then at Dorchester High School, where he was selected twice to be a member of the Greater Boston All Scholastic Team.

After high school, Fraser moved to Waterville to attend Colby College. At a time when football helmets were optional (and made of thin leather at best), Fraser became a member of the varsity team in his very first year at Colby. He was followed to college several years later by his brother Allan, who also played on the varsity team of which, by then, Fraser was captain.

In his senior year in 1914, Fraser made his school proud by leading Colby to wins over Bowdoin (48–0), Bates (61–0) and the University of Maine (14–0). By then named All Maine halfback, he also led Colby to the state championship against the U.S. Naval Academy. Although his team eventually

lost the Maryland matchup, local newspapers claimed the game "one of the finest exhibitions of football ever seen at Annapolis."[53]

Upon graduation, Fraser served in the athletic department of Waterville High School and worked for the Maine State YMCA as a swimming instructor before transferring to Everett High School in Massachusetts to become athletic coach and part of the academic faculty.

In April 1917, the United States entered World War I. Fraser and his older brother Harold filled out their draft cards, and younger brother Allan joined the merchant marines. Within months, however, tragedy struck: Allan was drowned in an accident aboard ship.[54]

With no time to grieve, Fraser was sent for one year to Spartanburg, South Carolina, where the army named him second lieutenant of the First Maine Heavy Artillery. He then left for France, where he was stationed for three months on the French front of the Meuse-Argonne Offensive, a final major Allied assault that would be the war's largest—and deadliest—for American troops.

World War I was the first war in which chemical warfare was employed, and the results were devastating. The soldiers were suited with gas masks and other protective equipment, but Fraser quickly discovered that his men could not hear him through the mask. Because of his rank, he needed to have clear communication with troops on the front at all times and was thus forced to lift the mask, and expose himself to deadly chemicals, each time he issued an order.[55] Although he was luckier than many with respect to his injuries, the exposure to deadly mustard gas would cause irreparable damage to his heart.

While still in the military convalescence hospital in France, Fraser would be dealt yet another blow. Just months after the Armistice was signed at Versailles on November 11, 1919, his younger brother Gordon—who had desired to follow his brothers into patriotic service—died while in training for the marines at Parris Island, South Carolina.[56]

Not only did World War I bring with it millions of battle casualties, but it also facilitated the spread of a then new influenza A virus subtype: a deadly H1N1 strain that was known as the Spanish flu. It reached pandemic levels by 1918 and was particularly rampant among troops of the navy and marines. In all, this flu killed an estimated fifty million worldwide—more than the war itself—and among the victims was Fraser's young brother.[57]

"Gordon was a soldier. I am a soldier," Fraser wrote home to his heartbroken family in a letter written on New Year's Eve 1918. "There can be no nobler death to die than in the service of our country."[58]

After he had healed from the immediate injuries of war, Fraser returned home to dedicate himself again to what he knew best: teaching, coaching and, when he was stronger, athletics. In addition to playing football, baseball, basketball and tennis, Fraser was a skilled marathon swimmer, participating in several twelve-, fourteen- and even sixteen-mile swims, including the Portland to Peak's Island swim and a race in Lake Ontario.[59]

Fraser's first professional position following the war was as athletic director of Coburn Classical Academy in Waterville, where he remained for three years, producing top athletic teams for the school. There, he met a beautiful and scholarly young Latin teacher and fellow Colby graduate from Calais, Mary Phyllis St. Clair. They fell in love and were married in 1920.

In 1922, Fraser was hired by the Westbrook Community Association as its athletic director and executive secretary, and the couple relocated to Waltham Street—and later to East Bridge Street—in Westbrook. He was

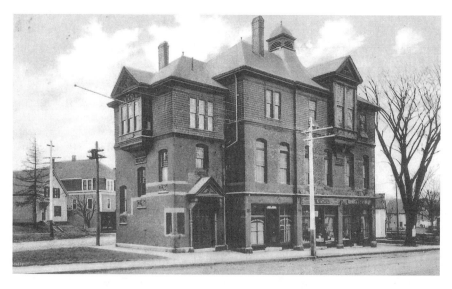

A postcard of the Warren Block building, built in 1882. The Westbrook Community Association Gymnasium and Fraser's offices were housed here on upper floors. The building was added to the National Register of Historic Places in 1975. *Courtesy of the Westbrook Historical Society.*

put in charge of the Cumberland Mills Gymnasium, the "old swimming tank" once located under the Cumberland Mills "black bridge," the clay tennis courts and all playing fields and community sports.

A historical society note from a gymnasium co-worker speaks of Fraser's dedication. He was often seen maintaining the clay courts by hand and even contributed financially to the upkeep of equipment during the Great Depression when the community had no funds available.[60]

The Frasers raised six children in Westbrook, and the entire family was deeply involved in the community. In addition to his position with the Westbrook Community Association, Fraser served on the school board from 1927 to 1929 and was both a science teacher and a football coach at Westbrook High School from 1929 to 1933. In all of his years in Westbrook, he took only one break from his duties to help coach the Bowdoin College team of 1927–28.

Fraser (seated, in white at far left of second row) was the coach of Westbrook's 1933 championship baseball team of the Telegram League. Some of the players named in the photo are: Roland and Bob Tetrault, Henry Cote, Armand Daniel, Lloyd Spiller, Harlan Shane, Ronald K. Jordan and Philip W. Nelson. *Courtesy of the Westbrook Historical Society.*

Mrs. Fraser was an active member of a local literary club and served as president of the Westbrook Women's Club, while among their children were a valedictorian and—of course—several star athletes.

Despite Fraser's great strength and physical fitness, two decades after the conclusion of the war in which he had fought with great courage, his injuries proved overwhelming. He died of a massive coronary while at work after a simple game of badminton on April 11, 1938.

That same year, Westbrook honored the esteemed coach and teacher with the dedication of Fraser Field, and Colby honored him by proclaiming its homecoming Friday "Paul Ginger Fraser Colby Night."

Members of the Westbrook Historical Society and a number of his descendants, including his youngest daughter Janet Mitchell of Waterville, have made sure that this brave and beloved man will not be forgotten. Fraser Field was rededicated in 2000, and the handsome stone monument that speaks of a courageous and respected soldier, teacher and coach was placed along the riverbank.

A Woman in Two World Wars: Hello Girl Hero to Bizerte Prisoner

Ruth Couturier Simon (1894–1963)

In July 1942, Ruth Couturier Simon watched in horror as skirmishes between the Allied British and the Vichy French shattered the area around her home in the Mediterranean port of Oran, Algeria. She had fallen ill just months earlier, her experiences during the German invasion of France taking a heavy toll on her health.

"It was terrible as I watched the...scene from my bed," she wrote from Oran to her sister Gabrielle Lucas of Westbrook. "The bombs thrown by the English aviators on French ships made geysers...100 feet high in the water. All night long a ship burned. It was a tragedy to say the least."[61]

Born in Westbrook on April 22, 1894, Simon, baptized Ruth E. Couturier, was no stranger to war. She had served during World War I in France as part of the U.S. Signal Corps, an important branch of the army that provided communications between command stations and troops on the front.

One of twelve children of French-Canadian immigrants Dr. Adjutor and Adeline (Tremblay) Couturier, Ruth Couturier attended Westbrook schools while her father served as city physician for many years from the family's Brown Street home. World War I erupted just one year after Couturier's 1913 graduation, with troops from her parents' Quebec home joining the conflict almost immediately. When the United States entered the war in

April 1917, Couturier, along with her brother Jean, decided to join the fight. Jean spent the duration of the war in Jacksonville, Florida, while Couturier was quickly sent abroad with the Signal Corps.

This unique female corps was created at the start of the war by General John Pershing, the army's commander in chief. To attract members, recruiters advertised in newspapers throughout the country. Enlisted army men had originally been trained to perform these operator duties, but Pershing wanted them available for line repairs and other necessary physical operations on the front. Calm, dedicated women, he decided, would be well suited for the job. Signal Corps members were required to be healthy, single and fluent in French.[62]

Twenty-three-year-old Ruth Couturier answered the call, and of about 7,000 applicants, she was one of about 350 chosen to become a member of the "Hello Girls." She accompanied the fourth unit of operators to join the war in France in 1918.[63]

The members of the Signal Corps were sworn into the army, subject to the same regulations and issued uniforms and dog tags—as well as gas masks and helmets—after completing their basic military procedural training at what is now Fort Meade. After the Armistice, however, the women who had given much to the war effort were greeted with an unwelcome surprise as they applied for their honorable discharges: army regulations were worded to include only men, and thus, their applications were denied. Despite their invaluable contributions to the war, the regulations placed upon them and their official swearing in, they were considered civilians, not actual service members. It wasn't until 1978 that President Carter finally signed the bill that would give the women—only a number of whom were still living—their appropriate veteran status.[64]

Despite this disappointment, Couturier's experiences in the war were life changing. In addition to the horrors and triumphs that undoubtedly accompanied her service, it was while serving in France that Couturier met a young French naval officer and meteorologist named Hervé Simon. Although Couturier returned to Westbrook after the war to work for many years as a stenographer with the Veterans' Administration at Togus, the French officer was not forgotten. In 1933—more than a decade after the end of the war—she finally set sail for France to become Mrs. Simon.

Although Lieutenant Simon was from the Brest area of France, the couple settled in Paris. They remained there until the German invasion of World War II, when they were pushed south to Cannes and then to the Algerian port city of Oran (then a French protectorate and home to large French, European and Jewish populations), where they hoped they would be safe.

But there, while her husband was away at sea, tension between the British and German-aligned Vichy government mounted. "We are living on almost nothing," she wrote to her sister at the time. "No butter, milk, potatoes, coffee, meat…I can't get the medicine I need nor the proper food…all on account of the English blockade."[65] When the conflict escalated even further, Simon sent her housekeeper and stepson away to safety while she, too sick to relocate, faced the British bombardment alone.

On November 8, 1942, shortly after Couturier's letter arrived in Westbrook, American and British forces commanded by General Dwight Eisenhower launched an invasion—called Operation Torch—on Moroccan and Algerian sites. The goal was to push German control out of North Africa and set up bases for the planned entrance into Sicily, Italy, and other Axis-controlled countries in southern Europe. Operation Torch was the first major American offensive of World War II

The Allies hoped that the French, long-standing friends of the United States, would cooperate in the landing and join in the fight against the Germans. Clandestine meetings were arranged and agreements forged. Military officials, however, could not openly alert the Vichy government—put in power by the German occupation—to their plan. They began the landings—18,500 troops at Oran alone—with the orders to fire only if fired upon, and they hoped that the French would join them. Some, including Captain Hervé Simon, did so quickly.[66]

Due to miscommunication, confusion or the instinct to protect their territory, however, many Allied troops encountered French resistance while others were openly welcomed.[67] On November 9, Oran—and a somewhat bitter Vichy government—surrendered and reluctantly joined the fight against the Axis.

But Hitler and Mussolini did not sit idle. While the Allies' offensive on North Africa began, German forces, commanded by Field Marshal Irwin Rommel, moved into Tunisia, taking control of the country that had been

under French rule since June 1940. In typical Nazi fashion, they began rounding up Jewish workers to clear rubble from bombed sites. Eventually, the Nazis sent many to labor camps scattered throughout the region to further "contribute to the war effort."[68]

Because her husband had so readily joined the Allies, shortly after Simon's letter was written from Oran, she and her fourteen-year-old stepson Marcel were taken prisoner (either by Nazis or by Vichy figures displeased by her husband's actions) and sent to one such camp in Bizerte, Tunisia.

The Bizerte camp was one of the worst in North Africa. Infested with lice and living in cold, crowded quarters, prisoners were starved, overworked, beaten and even murdered.[69] According to a journal kept by Jacob André Guez, a Jewish prisoner of the camp, the malnourished workers went about their work as best they could, trying not to attract attention while hoping that the Allies would arrive quickly.[70]

After six months of hard fighting between Allied troops and the desert-hardened *Afrika Korps* led by Rommel, Tunisia finally fell to the Allies on May 13, 1943. While a French, British and U.S. victory parade was held in Tunis on May 20, the forces did not pass through Bizerte until early July.

Among the troops that finally arrived at the camp was a young member of the Army Medical Corps: Private Bertrand Couturier. He was Ruth Simon's youngest brother. Aware that his sister was in the Bizerte camp, he arranged to be among those who liberated the prisoners. He found his sister and her stepson weak and emaciated. Shocked and sickened by the condition of the prisoners, he wrote of the experience to his sister Francoise Couturier of Cambridge. Their sister was alive, he informed her, but barely. When found, Simon weighed only fifty pounds.[71]

Simon was treated by the Red Cross while her husband continued to fight until the close of the war, and she eventually recovered her health. The couple moved back to the United States, first to Portland and then to Central Falls, Rhode Island.

Simon's husband, Hervé Simon, died at the Naval Hospital in Brighton, Massachusetts, in 1962 at the age of fifty-nine. Simon herself followed just one year later, one month before her seventieth birthday. They were quietly buried in Westbrook's St. Hyacinth Cemetery, accompanied by a ceremony that likely remarked in some way upon their extraordinary experiences. While their graves should have borne two small flags of service—one

American and one French—it was not until November 1978 that Simon's long overdue Stars and Stripes were added.

With President Carter's declaration finally rewarding veteran status to the "Hello Girls" of World War I, Simon was admitted posthumously to Westbrook's Stephen Manchester American Legion Post, and a flag was placed near her stone by Mr. Edward Powers, a fellow Westbrook veteran she had known while in France.[72] After living a lifetime that spoke of great courage, great hardship and great sacrifice, Ruth Couturier Simon was finally given the military honor she deserved.

A Remarkable Life Indeed

Alfred R. Pugh (1895–2004)

Maine has often been referred to as "the whitest state in the Union." Particularly outside of Portland and the other modest metropolises scattered around the state, the lack of extensive cultural and racial diversity was quite noticeable up through the 1980s and early 1990s. In fact, this is still the case in many areas today. That, however, does not mean that Maine is without its own black history. Due to often limited documentation and the smaller percentage of people of color (compared to larger and more southern cities within the United States), one must dig a little further to uncover the rich story of black Mainers that extends back four centuries.[73] From Cape Verde fishermen in the times of the earliest European colonists to men (and, later, women) who served in every American military conflict from King Philip's War—the first great colonial war—to the present wars in the Middle East,[74] most Maine communities from China to Westbrook itself have included many interesting and noteworthy citizens of diverse backgrounds.

Alfred Pugh's story does not deserve attention solely because of his racial heritage or because for many decades he and the members of his household comprised one of the only families of color residing permanently within Westbrook's city limits. He deserves recognition simply because he was a

remarkable individual. Pugh's achievements included serving his country in World War I, where he took part in the Meuse-Argonne Offensive—American troops' largest and deadliest confrontation of the war—during which he was severely wounded by exposure to deadly mustard gas. For his service, Pugh was awarded the Purple Heart and was also decorated in 1999 by the Ordre National de la Légion d'honneur (National Order of the Legion of Honor), the highest distinction in France. Pugh was finally brought to national attention before his death in 2004 at the very ripe old age of 108: he was, at that time, the country's oldest living wounded combat veteran.

Alfred Raymond Pugh was born on January 17, 1895, in Everett, Massachusetts. Pugh's father, William J. Pugh Jr., was a carpenter, blacksmith and factory worker from Virginia, and his mother, Jane (Roberts), had, according to census records, immigrated to the United States from the Turks Islands (in the West Indies) in 1882. When Pugh was a toddler, the couple moved their family to Westbrook, where his father secured work and built the home on East Valentine Street in which he and his wife would raise their twelve children.

When Pugh first came to Maine, life was very different from today, to say the least. Grover Cleveland was president; French impressionists Claude Monet, Edgar Degas and Mary Cassatt and writers Mark Twain and Sir Arthur Conan Doyle were living, modern figures; and Al Capone and Amelia Earhart had yet to be born. The Wright brothers had not flown, the Model T had not been built and there were no calculators, ballpoint pens or disposable razors. Milton Hershey hadn't even begun making milk chocolate, as the process for which was still a special—and very expensive—European secret. Homes did not have microwaves, vacuum cleaners, televisions, air conditioners, washing machines, stainless steel pots or presliced bread. Antibiotics had not been discovered; cholera, typhoid and tuberculosis were still common and very deadly diseases in this country; and the world was in the midst of its last major outbreak of the bubonic plague.[75]

In the late 1890s Susan B. Anthony was fighting for women's suffrage (which wouldn't arrive until the passing of the Nineteenth Amendment in 1920), yet black women were excluded as members from the National Women's Suffrage Association. That same year, just one month after Pugh's birth, Frederick Douglass—writer, abolitionist, civil rights leader and former

slave who had traveled the country since 1841 speaking out for equal rights for all—passed away. At this time, segregation of churches, theatres and in train cars was common practice—even here in Maine—and lynching of African Americans in the southern United States was still an all too frequent occurrence. Seven months after the death of Douglass, Booker T. Washington gave his "Atlanta Compromise" speech, which pressed for access to vocational training and other educational opportunities for people of color, for southern employers to hire black workers and for leaders to stop ignoring violence against African Americans but, effectively, agreed (in front of this mainly white audience in Georgia) to the principle of segregation.

Just one year later, the noted *Plessy v. Ferguson* decision was made by the Supreme Court, upholding the legality of racial segregation on public transportation. This decision would not be overturned until 1954 with the court's vote on the historic *Brown v. Board of Education*, which finally brought a long overdue end to the federal legality of such practices.

Despite the tone of the nation at the time of Pugh's childhood and undoubted challenges faced by this hardworking and numerous family of biracial heritage, in later interviews, Pugh remembered his life in Westbrook with the greatest fondness.

Alfred "Dolly" Pugh's graduation photo, Westbrook High School, 1915. *Courtesy of the Westbrook Historical Society.*

Pugh, a member of the local Methodist church and one of Maine's first Boy Scouts,[76] attended Westbrook schools up through graduation. His 1915 yearbook, showing a handsome young man nicknamed "Dolly," speaks of a charming and cheerful lad who was well liked and very involved in his class. "If there is anyone in school who does not know Dolly, he ought to be given the Third Degree," it reads.[77] Pugh played baseball throughout his youth, continuing as part of the Westbrook High School team while he was a student. He also served as class president during his junior year.

When the war broke out in Europe during the summer of 1914, the youth of Westbrook—along with the rest of the nation—paid close attention to developments, due undoubtedly in part to the compatriotism the city's sizeable Franco-American population felt for the French. In a later biography, Pugh speaks of learning the French language as a small boy and of a classmate who insisted on teaching his high school class the French national anthem "La Marseillaise," which was later sung at school assemblies following the "Star Spangled Banner."[78]

At the time of Pugh's graduation, the United States had not yet entered the conflict. He later said that if there had been a war to enter, he would have signed up right away.[79] Thus, Pugh sought employment at the local Western Union office and was hired as a telegraph operator. He soon transferred to the Maine Central Railway Company to work in the same position.

When the United States did enter the war in 1917, Pugh, along with his two older brothers John and Norman, filled out his enlistment card immediately. He entered into intensive training, and after six months of preparation with the U.S. Army's infantry, Pugh was assigned to the Seventy-seventh Infantry Division and sent off to France.

Pugh would never forget the welcome his ship received from the grateful French. "Thousands of French citizens lined the docks to welcome the troops, waved American flags, cheered, and sang."[80] Pugh, however, was soon faced with the grim realities of war. He was stunned by the complete devastation of the area of Verdun,[81] which had, during the previous year, been the site of a brutal ten-month-long battle between French and German troops that resulted in close to one million casualties.

Almost as soon as he arrived, word of Pugh's ability to speak French spread among infantry commanders. "They started moving me around a lot... Different regiments, Different missions...They'd put me out at the head of our convoys. I could read the signs. I could ask questions."[82] In combat, Pugh

Alfred Pugh and Westbrook High School's class of 1915. *Courtesy of the Westbrook Historical Society.*

was often placed toward the front because of his communication skills, and he advanced quickly within the ranks, promoted from private to sergeant in just over six months. Pugh became part of a small contingent of American and Canadian troops when the last major battle of the Great War—the Meuse-Argonne Offensive—began.

It was while on the front in the Argonne forest that Pugh, like many of his fellow soldiers, was gassed. Because Pugh had been placed so far forward in the lines, he took a major hit that he was lucky to live through. Chemical warfare, a new development in World War I, was utilized by the German military, which introduced the use of mustard gas dropped by airplane onto enemy troops. Exposure to mustard gas causes blisters and burns on exposed skin and can induce blindness and often fatal respiratory inflammation.

Pugh, having left his awkward gas mask behind, was knocked unconscious by his exposure to the gas and remained so for several days. When he awoke, medical personnel informed him that they had not expected him to survive.[83] After his convalescence, Pugh was assigned to help sort out the tremendous backlog of mail, much of which had been misdirected due to translation difficulties by monolingual staff. Although he pleaded to return to the front, despite his injured vocal cords, he would not see battle again, as the Armistice was soon signed to end the war.

Pugh remained in France for most of the remaining year, assisting with cleanup and restoration efforts. In spite of his wartime experiences, he would speak of those last months in France with affection. He fell in love with the countryside and the people and, while serving, even refused several offers to return home early—despite his injuries, which still merited attention. Those injuries would end up causing permanent damage to his vocal cords, leaving him speaking with a hoarse, raspy voice for the rest of his life.

Upon his discharge in July 1919, Pugh returned to his family home in Westbrook and to his work as a telegraph operator with the railroad company. He stayed in this position for many years before sensing that the end of the telegraph was imminent and deciding to seek employment with the post office as a mail carrier.

Pugh delivered mail to the people of Cumberland Mills twice a day through even the roughest weather, toting letters and packages—without the assistance of a vehicle or pushcart—until his retirement in 1962. He walked twelve miles a day during his twenty-six-year employment. A co-worker, Lawrence Wescott, later wrote, in a published birthday letter to Pugh, of Pugh's dedication and good nature: "He wasn't a big man, but he carried his load right along with the rest of us…I can remember him coming up and taking a route for someone who might have been ill…He always had a big smile and was a hit with all on his route."[84] Pugh was well liked and

remembered for always having candy in his pocket for local children—and dog biscuits for local canines.

In 1923, before beginning his work with the postal service, Pugh met and fell in love with a young woman named Irene, who would be his wife for fifty-three years. Although they did not have children of their own, their house was always full of unofficially adopted nieces and nephews whom they raised for months or years at a time when their own parents were unable to do so. In total, they lovingly cared for sixteen children over the years.

Pugh retired from the postal service in 1962,[85] and—after more than seven decades in Maine—he and his wife moved to Florida nine years later. Shortly before Pugh's wife passed away in 1986, he was struck blind due to macular degeneration, an irreversible disorder of the retina.

Pugh moved into the Veterans' Affairs Medical Center in St. Petersburg in 1996, where he enjoyed playing the organ, keeping up on world news and—each week—having Harry Foote's "Looking Back" section of Westbrook's *American Journal* read to him by one of his few surviving nieces.[86] As if to make up for his lack of vision, Pugh made a point of exercising his memory regularly, calling up dates and details of his childhood, his time in France and his life in Westbrook.[87]

In 1999, Pugh was named to France's National Order of the Legion of Honor, the highest decoration in France, an order established by Napoleon Bonaparte in 1802. When Pugh received the award, at age 104, he addressed France's consul general in French and received an ovation.[88]

By Pugh's 108th birthday, he had become known around the country as the world's oldest living wounded combat veteran. Visited by reporters and local schoolchildren alike, Pugh undoubtedly always had something to share, his hoarse-sounding voice a reminder to all who spoke with him of just how much he had given to his country.

When Pugh passed away on January 7, 2004, just ten days short of his 109th birthday, the world lost not only a remarkable man but also another key piece—a living record—of our country's history.

Maine Swooned at Crooner's Return

Hubert Prior "Rudy" Vallée (1901–1986)

O ne Friday morning in July 1930, a crowd of close to three thousand pressed into Portland's Union Station, eagerly awaiting the arrival of radio superstar and recent film actor Rudy Vallee. Cheering throngs lined the roads from St. John Street to Monument Square—and the squares and streets along the Westbrook portion of Vallee's auto parade route—hoping to catch a glimpse of the shiny 1930 Packard that held, to date, the city of Westbrook's most famous celebrity.

The following day at noon, local residents, along with many prominent visitors and film crews from Paramount and several other studios, packed into the area at the intersection of Westbrook's Bridge and Main Streets. Outside of the Vallees' Warren Block drugstore, a dedication ceremony had begun to christen the spot "Rudy Vallee Square." The streets were full and the crowd was ecstatic, welcoming home Westbrook's favorite son. Three days of citywide celebrations, dances and banquets followed, including a Monday event at which Vallee was presented the key to the city.

Although Vallee (given name Hubert Prior Vallée) was not born in Maine, but in Island Pond, Vermont, on July 28, 1901, his family moved to Westbrook when he was only four years old so that his father, French Canadian immigrant Charles Vallée, could take charge of the local pharmacy.

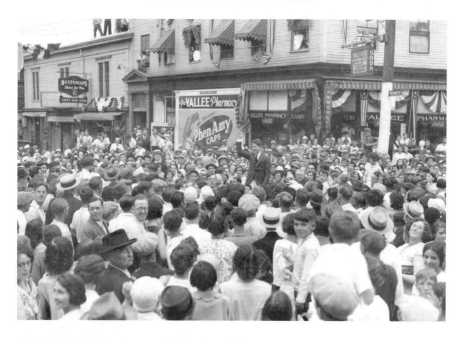

July 21, 1930: Vallee waves to his Westbrook fans, who not only crowd Main Street but also line the rooftops and second-story windows overlooking the square. *Courtesy of Michael Sanphy.*

The family made their Westbrook home first on Church Street and then on Monroe Avenue, and Vallee and his two siblings, William and Kathleen, completed their education up through high school in local schools.

The young Vallee demonstrated a particular interest in and ability for music from an early age, from snare drums to clarinet, and then on to the saxophone—an instrument whose manufacture had been brought to the United States only three decades earlier—when he was a teenager. By the time he joined the orchestra at Westbrook High School, he showed distinct skill for the instrument, and he soon took on the nickname of "Rudy" after the first American saxophonist great Rudy Weidoeft, of whom he was a dedicated fan.

While in school, Vallee assisted in his family's business, chipping and hauling ice, selling medicines and working the soda fountain. Mostly due to clashes with his father—which he contributed to their quick tempers in his 1962 memoir[89]—he soon left the pharmacy but soon got a job at the nearby Star Theater hand-cranking the movie projector. Vallee eventually became

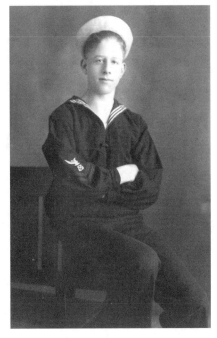

Above: Rudy's father, Charles Vallee, purchased the Vallee Drug Store in the early 1900s. *Courtesy of Michael Sanphy.*

Right: Rudy Vallee as a young man. He first enlisted in the navy illegally at the age of fifteen. *Courtesy of Michael Sanphy.*

an usher at the larger Strand Theater in Portland, and shortly after, while still a teenager, he began providing musical accompaniment to the theatre's silent films.

At fifteen, Vallee—already showing the tabloid-type antics of modern-day stars—faked his age and joined the navy, only to be discharged when the truth about his birth date was discovered. Retrieved by his father, he returned to school, and to performing.

Upon his high school graduation, by this time in a band that toured all over New England, he began his undergraduate studies at the University of Maine. He soon transferred to Yale, where he majored in philosophy, but he took his University of Maine memories—and the university's "Stein Song"—with him. He would later make the song an international hit; millions of copies of the sheet music would be sold and the lyrics translated into several foreign languages.

While at Yale, Vallee spent some vacation time performing with the Old Orchard Pier Orchestra and also traveled abroad to play at the Savoy Hotel in London. After Yale, he continued touring with a band called Rudy Vallee and the Connecticut Yankees. Their success led to a steady position in New York's fashionable Heigh-Ho Club, where Vallee coined the greeting "Heigh-Ho, everyone," a phrase he shouted out to the audience each night before he performed.

It was at the Heigh-Ho Club that Vallee began to sing, at first out of simple necessity: The band needed a singer in order to keep the gig.[90] Those who heard him, however, were struck by the soft, smooth voice that seemed to mimic his band's jazz instruments. A whole new style of popular singing was thus born—the "crooner"—paving the way for later singers such as Bing Crosby, Perry Como and Frank Sinatra.

Vallee soon became the host of the popular *Fleishman's Hour*, the first-ever radio variety show. Radio success led to numerous fan clubs, and flappers and other female fans began to flock after him when he performed, screaming feverishly and, reportedly, hoping to catch sight of his lips as he sang through a megaphone in larger venues.

Headlines in 1929 named him "the man of the moment...dreamed about, brooded over, longed for more than any other man in present day America." Another proclaimed Vallee "America's new great lover," following in the footsteps of Valentino and Lindbergh, and marveled at how he had

In 1930, Vallee poses at the soda counter of the Vallee Drug Store, where he had worked chipping ice and mixing fountain drinks while attending Westbrook High School. *Courtesy of Michael Sanphy.*

"crooned his way to $20,000 a week." An impressive weekly salary even by today's standards, this sum was even more remarkable in 1929. Even with the country entering into the Great Depression and its economy in shambles, these reported earnings would be equivalent to just over $249,000 today.

That same year, filmmakers decided to capitalize on the young star's fame and charisma and cast him in his first film, *Vagabond Lover*. By 1930, and his much-publicized visit to Westbrook, Rudy Vallee was, indeed, a superstar.

Vallee later went on to host several more much-loved radio shows, including the *Royal Gelatin Hour*, giving many well-known performers their starts, including Bing Crosby, Jack Benny, Victor Borge, Milton Berle, Katherine Hepburn and Louis Armstrong, to name a few.

In addition to working with many film and singing sensations, Vallee had the opportunity to meet the Queen of England; several presidents, including Hoover and Nixon; and Helen Keller. He even had a run-in with the infamous gangster Al Capone in which he chastised the mobster for interrupting a performance.[91] To Vallee's good fortune, Capone found the incident amusing and laughed it off.

Throughout his career, especially in the early years, many of Vallee's public musical performances broke previous theatre ticket sales records. He

also took comedic roles in thirty-three films and starred in the Broadway hit *How to Succeed in Business Without Even Trying* in the early 1960s.

Vallee was also known for singing in multiple languages, and one of his Italian language songs, "Vieni, Vieni" (1937), can be heard in the background of the restaurant scene from the holiday classic *It's a Wonderful Life*.

Vallee wrote several memoirs, had numerous television roles (including parts in *I Love Lucy*, *CHiPS* and the character Lord Marmaduke Fogg on *Batman*) and—in true movie-star style—had three brief marriages to glamorous women before meeting a fourth young beauty, who would become his wife of many happy years, Eleanor Norris Vallee.

Rudy Vallee died in Hollywood of surgery complications on July 3, 1986, several weeks before his eighty-fifth birthday, but he has not been forgotten by his fans or by the people of Westbrook; the city celebrated the rededication of Rudy Vallee Square, complete with a 1930 automobile, a bronze bust and his loving widow, in July 2009.

City-Raised Nun Witnessed Major Change in China

Sister Therese Grondin (1909–2004)

O n a cold December morning in 1950, Sister Therese Grondin awoke with a start. While asleep in her bunk in Kaying, China, she'd had a disquieting dream: a pupil had warned her that Red Army soldiers were approaching.[92]

Sister Therese rose immediately to bury and destroy all of the papers she could find: correspondence from family and friends in Maine, notes from her superiors in New York, as well as any records the diocese had kept of the Chinese sisters and other Catholics in the parish. She advised the other sisters to do the same.

Born on August 21, 1909, Therese Jeanne Grondin's deep faith began to ripen during her childhood in Westbrook and schooling at St. Hyacinth's School. Her faith and desire to serve in a religious order continued through her high school years at the Presentation of Mary Academy in Quebec.

The daughter of French Canadian immigrants, Herman and Anna (Auclair) Grondin, she came from a deeply religious and inspired family.[93] Of her six siblings, two brothers also dedicated themselves to religious service. Her older brother Emmanuel joined the priesthood and worked with the Portland Diocese until his retirement, and the younger, Gerard (Jerry), later became a missionary priest and founded a congregation in Musoma, Tanzania.

Grondin entered the order herself on October 15, 1929, at the age of twenty and chose a particularly demanding path. Maryknoll, its center located in Maryknoll, New York, is a distinct Catholic order in which members dedicate their lives exclusively to overseas mission work. While earning a bachelor's degree in French, Grondin took her final vows with Maryknoll in 1935. She took the religious name of Marie Marcelline, the name of a younger sister who had died in infancy.

An eloquent writer with a thirst for higher learning, Grondin became a teacher within the Maryknoll organization. Her first overseas assignment was in the Guangdong Province of South China. She was twenty-six years old.

Within several years, she was appointed as novice mistress of an order of local nuns in the Kaying Diocese, also in southern China, where she remained until 1950. Grondin was present in China during the Japanese invasion that began in 1937. She remained throughout the lengthy World War II Japanese occupation—a period know for brutality, oppression and numerous human rights violations—until its end in 1945, often surviving by hiding in remote mountain villages with nothing but sweet potatoes for sustenance.[94]

It was in 1949, however, that Grondin witnessed the deepest changes within China. The country had emerged from the war depleted both economically and spiritually, and the military's resources and strength were equally exhausted.

The Communist leader Mao Tse-tung saw his opportunity and immediately began challenging the war hero Chiang Kai-shek's Nationalist government. A civil war ensued and continued for four years, resulting in the takeover of Mao Tse-tung and Chinese Communism.

In a later interview, Grondin described the first year following the takeover as a time of "toleration and quiet indoctrination."[95] This quickly changed into an iron policy in which persecution became common, and religious freedom and other personal liberties were deeply threatened.

It was at this time—December 1950—that Grondin awoke from her dream and set about hiding and burning anything that could be used against her. At 9:00 a.m., thirty soldiers rushed in, surrounding the convent and bursting into the classrooms.

Although the commander ordered her into the rectory where the other nuns and priest were being held, Grondin insisted on following as the soldiers

began a determined search of the compound. She was shocked when a commander pulled a box of several cartridges from behind a filing cabinet.[96] Grondin knew immediately that the fate of the sisters had been decided—at least for a period of time—by the Chinese commanders. The bullets had clearly been planted along with other "evidence" of the congregation's crimes and used both as proof and in hopes of pulling dedicated Catholic followers waiting outside away from their newfound faith.

Grondin was arrested, and she endured fifteen weeks in various primitive Chinese prisons, forced hikes through the hot hills and mountains and intense interrogations. One main goal of many of the questioners was to force her to renounce her faith and state that labor had "created the world."

Grondin gently countered each statement with a logical and intelligent counterargument. She articulated the experience in a 1953 memoir: "Labor does much, but not all," she said to the interrogator. "If there were no sun, there would be no growth...Without sun and rain, all of the labor in the world won't make it grow."[97]

Although the frustrated interrogator informed her that she would remain in prison until she changed her mind, she was released on March 17 and expelled from China along with all other Maryknoll sisters and priests.

She was saddened to leave China and the parishioners with whom she had worked for almost fifteen years. As a well-educated woman, she was particularly distraught about abandoning the women and girls whom she had come to know who were, at that time, often uneducated and treated very much as second-class citizens within the structure of male-dominated rural Chinese traditions and culture.[98]

Grondin, however, had no choice but to return to the United States, where she continued her studies at Duquesne University in Pittsburgh. Grondin also took time to spread word of her experiences through numerous interviews before returning to Asia in 1954 to serve as teacher and assistant principal at a Maryknoll school in Hong Kong. There, she wrote, among other things, a book titled *Sisters Carry the Gospel* for Maryknoll Publications.

She served in Taiwan and Thailand for twelve years, where, in addition to her mission work, she continued to write poetry and ever-eloquent correspondence with family and friends.

After returning to the Maryknoll Center in New York to work briefly in the development department, she was given her final assignment in Asia,

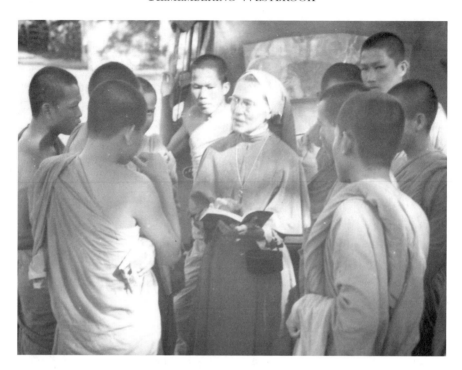

Above: Sister Therese Grondin at work with a group in Thailand, circa 1965. *Courtesy of the Maryknoll Mission Archives.*

Left: Sister Therese, circa 1989, dedicated her life to God's work through Maryknoll. *Courtesy of the Maryknoll Mission Archives.*

where she worked for several archbishops and bishops, utilizing her finely tuned secretarial skills and translation abilities.

Grondin returned to the United States in 1993 due to failing eyesight. She cared for the aging and ailing at the Maryknoll Residential Care facility until her own health began to deteriorate and she, too, required care.

Sister Therese died at the Maryknoll Center on June 30, 2004, just before her ninety-fifth birthday. She was buried alongside her sisters, her fellow nuns. She is survived by a number of nieces and nephews still in Westbrook and other parts of the country, all proud to recount tales of their aunt, a brave and determined woman who dedicated most of her life to helping others and to serving God.

Funeral Director Fights
Urban Renewal—And Wins

John Westbrook Hay (1910–2003)

According to fossil records, Jurassic giants munched on the foul-smelling fruits of female ginkgo trees over two hundred million years ago. One living species—the ginkgo biloba, called "a living fossil" by botanists—is the only remaining member of an order of trees that predates the arrival of dinosaurs. Although today no wild examples of the tree remain, the stately ginkgo and its relatives once grew abundantly in North America, Europe, Asia and Greenland.

Scientists believe that the wild population of ginkgos and other trees of that order were wiped out in most areas by the spread of glaciers over two million years ago. In fact, they were assumed extinct until cultivated ginkgos were discovered in Japan and China in the late 1600s. Seeds were then brought to Europe by naturalists and eventually made their way to North America about a century later.

"It's a hardy tree," says Doug Eaton, Westbrook's city arborist, "with a high resistance to disease and insects."[99] The gingko today, if left alone, can live for more than five centuries. There are examples in Asia that are several thousand years old.[100]

John W. Hay knew something about ginkgo trees, and he knew another fact that many of us do not: Westbrook is home to one of Maine's largest.

The ginkgo tree species evolved before the time of the dinosaurs. This tree shown, much like Westbrook's own, keeps watch over a public garden in Bordeaux, France. *Photo copyright Cor Kwant, the Ginkgo Pages (2009). http://www.xs4all.nl/~kwanten/index.htm.*

This ginkgo—a male, sans the odorous fruit—is located on Main Street, and Hay had the honor of watching it grow (albeit exceedingly slowly) in proximity. A neighbor had planted the shade tree with fan-shaped leaves next to the brick house in which Hay lived out his entire life.

John Westbrook Hay was born in that Main Street home on February 15, 1910, the son of Marion (Stimson) and funeral director Harry F.G. Hay, then mayor of Westbrook. The younger Hay's middle name was selected by his uncle, who thought it most fitting for the son of the city's mayor. It turned out to be a suitable name indeed for a man who served the city of Westbrook throughout his life until his death in 2003.

Hay, along with his three siblings, attended Westbrook schools up through graduation. Well liked, athletic and very active in the community even as a teen, he served as both class president and captain of Westbrook's football team in his senior year in 1928.

Hay later attended Bowdoin College, where he majored in biology and continued to be involved in student government. Despite an ankle broken on the sports field during his freshman year, he made important contributions to both the track team and the varsity football team in each of his college years. Throughout his time at Bowdoin, a relationship blossomed between Hay and Effie Knowlton, a bright and pretty Westbrook girl whom he had known since childhood. They were engaged during Hay's senior year and married the week of his college commencement.

Encouraged to enter the family funeral business, he and his young bride left Maine immediately after his wedding for Ohio so he could attend the Cincinnati School of Embalming (now Cincinnati Mortuary School), the oldest school of its kind in the United States.

Hay became one of Westbrook's two funeral directors almost as soon as he finished school and returned to Maine in 1933. His father retired at that time in order to dedicate himself to banking and sold his business, and the Hay house, to his son.[101]

Adjusting quickly to his new vocation, Hay took on his responsibilities with professionalism and compassion. The funerary business is anything but easy, but the customs of the 1930s brought particular challenges. Carefully orchestrated by the funeral director, all preparations—from embalming to funeral ceremony—were performed in the deceased's home.[102] Everything from chairs to embalming tools had to be transported by the mortician. Hay

Home of John Hay, Main Street, Westbrook. Photo early 1900s. *Courtesy of Michael Sanphy, Warren Memorial Library Photographic Collection.*

cared for many in death, from mill accident casualties to plane crash victims to those killed in trolley accidents and fires. He prepared many for their final resting place, children and elderly alike, a great number of whom he would have known or even been close friends with.

Dealing with death on a daily basis, however, did not sour Hay's personality or turn him bitter or morose. His four children remember him as a humorous, kind and affectionate father—albeit one who was always on call. His daughter Dorcas remembers, "Until a housekeeper was employed in later years, he was never able to leave the house, or even go out into the yard, with my mother. Someone always had to be at hand in case the phone rang."[103]

Not only did Hay need to be available to guide the way for families who had lost a loved one, but he was also on call for emergencies, as he owned one of the only two ambulances in the city.[104] Until police departments began providing emergency transportation in the 1950s, each municipality was mandated to have an ambulance operator present, and this duty often fell to the town's funeral director. Thus, Hay was both responsible for preparing the dead and, in some cases, helping to save the living.

Hay was called upon for transport within Westbrook but often to other nearby towns as well. Daughter Deborah Bird recalls that in 1947, when great forest fires developed in the Brownfield/Fryeburg area, Hay was at the scene. Fearing that the hospital would have to be evacuated, authorities called upon all local rescue drivers to report to the area. "The glow," son Peter Hay recounts, "was visible from downtown Westbrook." Brownfield is over thirty-five miles away.[105]

Busy with funeral preparations and emergency transport, Hay's work calendar was always full. Hay referred to himself as a workaholic, but his strong labor ethic and busy schedule were a result of an honest dedication to his profession and to the families he served.

Although Hay steered clear of politics, believing that business and government shouldn't mix, he continued the tradition of community involvement that had emerged in his high school and college years. Hay, for example, was appointed as trustee of the Walker Memorial Library in 1954, becoming part of a select group responsible for the city library's finances and governing policies. A vocal advocate for the library, he served in this position for over four decades.

In addition to his community work, Hay regularly contributed to a long list of charities. He was the county treasurer of the National Foundation for Infantile Paralysis, which later became the March of Dimes. With that organization, he worked to raise money for children and families struck by polio's devastating effects.

An active member of the Westbrook Historical Society, Hay also held a great interest in our past, from the Civil War—which he often spoke about to local groups—to local history. When the Walker Memorial Library set to work on an oral history project in the late 1970s, Hay, then age sixty-eight, was one of the residents chosen to record his thoughts. Today, the simple binder marked "Notebook 16" tucked into the library's Local History Room holds the transcript of Hay's words. In it, he paints a picture of the Westbrook of the 1920s in which he grew up, of his school days, of sports and even of scaling the S.D. Warren smokestack—which originally stood over 350 feet high—the night before his last high school football game.

"Today I can imagine what I would do if a grandchild of mine attempted such a thing," he added.[106] And one can almost see his wry smile and shake of the head.

Hay was proud of being from Westbrook, and when pieces of the city's history were threatened in the 1970s, he took notice. Among a list of

John and Effie (Knowlton) Hay, circa 1980. *Courtesy of Hay family.*

alterations to the face of Main Street, the gingko tree that he and his wife had grown to love, with its heartiness, history and beautiful golden color each fall, was in danger of being destroyed. City planners wanted to remove it to make way for a parking lot.

Hay, deeply upset at the thought of losing such a distinctive tree, made a few phone calls. Thus, today, the parking lot in question is slightly shorter than originally planned. The tree remains, modestly tucked behind the gazebo near the former Hay house. It provides a shady refuge in the summer and an impressive sight for anyone fortunate enough to catch its leaves dropping like rain each autumn when it can shed the whole of its abundant foliage in about one day.

Hay aided the residents of Westbrook, kindly and capably, in their times of greatest need, and he is remembered fondly by all who knew him. He continued as funeral director until his health began to fail, and he sold his business to Blais Funeral Home in 2001. He said goodbye to his lifelong home—and the now well over a century-old gingko tree—trusting us, the Westbrook citizens whom he served for so many years, to look after it. Hay died on April 1, 2003, just two years after his dear wife Effie.

Big Dreams Come True for Pioneering Air Hostess

Alice Lemieux Jacobsen (1921–)

As a teen, Alice Lemieux dreamed of seeing the world. The pleasant candy counter worker never imagined, however, that by age twenty-five she would have participated in an emergency rescue in Newfoundland, modeled for advertisements in New York City and circumnavigated the planet.

Lemieux was born in September 1921, the daughter of Rudolphe and Elizabeth (Gallant) Lemieux. Rudolphe was an immigrant from Quebec who made his living at the S.D. Warren paper mill, and Elizabeth had come to Maine from Prince Edward Island. Both were proud Americans, busy with their eight children and very involved with St. Hyacinth's Catholic Church.

Now eighty-seven (2009) and living in Monmouth for the summer and Arizona the rest of the year, Alice Lemieux Jacobsen remembers growing up in her family's succession of modest homes on River, Webb and then Bridge Streets: "We had only one brother, and the seven girls all shared a room. We'd get giggling most nights…until my father would call up the stairs and scold us. We had a lot of fun together."[107]

Throughout high school, Lemieux worked at the candy counter of McClellan's five-and-ten on Main Street. She is remembered by then co-worker Ellie Conant Saunders as "the nicest girl; always with a big smile on her face."[108]

Throughout high school, Lemieux worked at the candy counter of McClellan's five-and-ten on Main Street. *Courtesy of Michael Sanphy.*

In 1945, four years after graduating from Westbrook High School, Lemieux received an invitation from an uncle in Connecticut that would change her life. He suggested she come to look for work while staying with his family in Hartford. The amiable Lemieux quickly found employment in the personnel department of Pratt and Whitney, which has manufactured aircraft engines since 1925. Encouraged by clients, she soon decided to apply for a position with American Airlines in New York.

Lemieux was hired as a reservationist and moved, alone, to New York City, where she lived in Jackson Heights. Shortly after beginning with American, she heard of openings for stewardess positions with Pan Am. The profession was new and sounded very exciting. Pan Am had only begun hiring female crew members in 1944, just two years earlier. Lemieux put together her application—and headshots that would make a Hollywood beauty envious—and waited.

Fluent in French from her upbringing and education at St. Hyacinth's School—a plus for the internationally flying Pan Am—she was hired immediately and began her training. Lemieux was taught first aid and

emergency procedures but was also instructed in the fine type of service then expected by airline passengers.

At the time, air travel was reserved for the wealthy and elite. An average ticket cost about $500, which, with inflation considered, would be equivalent today to about $5,100. Service included elegant, printed menus, fine china and silver place settings and comfortable foldout "sleeperette" berths. Lemieux encountered movie stars, sports figures, dignitaries and politicians on almost every flight.[109]

It was an adventure, but it was hard work, and not all of Lemieux's experiences were memorable for positive reasons. In September 1946, still in her first year as a flight attendant, she found herself at the scene of a crash rescue site in Gander, Newfoundland.

It happened like this: while returning to the United States from Ireland, the pilot of her Pan Am flight spotted a shattered DC-4 Sabena passenger craft in a swampy, wooded area outside of Gander. The pilot landed so that the crew could join the U.S. Army, Coast Guard and civilian rescue team.[110]

Lemieux accompanied local medical workers to provide first aid and food to the victims.[111] Of the forty-four passengers and crew aboard, only eighteen survived. The rescue effort was later referred to as "the Miracle at Gander" because of the extreme difficulties encountered by the rescue team. This was the first major rescue effort in history performed with the aid of helicopters, which, in order to reach Gander from where they were based in New York, had to be disassembled, flown to the site and reassembled—all achieved in less than forty-eight hours.[112]

While in Westbrook to recuperate from the experience several weeks later, Lemieux told a reporter that the emergency rescue operation was "a sight long to be remembered."[113] But the incident did not deter her from returning to work.

The following year, Lemieux received an unexpected telegram from her superiors: she had been selected as sole stewardess aboard the first round-the-world passenger flight in aviation history. Though surprised—because she was not the senior flight attendant for Pan Am (nine others outranked her)[114]—she packed her bags.

The historic Pan Am clipper flight, traveling over twenty-two thousand miles in thirteen days, was packed with publishers and editors of U.S. magazines and newspapers. They departed from LaGuardia in June 1947 accompanied by sixteen army and navy fighter planes in combat formation.

Alice Lemieux, looking "charming and dewy-eyed" in her Pan Am uniform. *Courtesy of Kathy Jacobsen.*

The flight schedule was planned so that passengers could sleep on board each night and arrive for scheduled daytime functions in each of the cities they visited. Although Lemieux and other crew were invited to attend these events—and Pan Am led the press to believe they did—sleep was the more attractive option. While the passengers relaxed and slept at night, the crew was awake and working. Sleep was especially essential for the

photogenic Lemieux, who was expected to be "charming and dewy-eyed" for photographers each day.

Lemieux found herself more in demand than ever after this historic flight. National advertising companies wanted her to serve as spokeswoman for products such as fur coats and cigarettes (despite the fact that she never smoked), and Pan Am and her passengers demanded her for other important events, including the inaugural flight to Johannesburg, South Africa.

Back in Westbrook, her father kept careful scrapbooks of all her adventures and achievements. Several of her sisters, inspired by her experiences, also decided to move to New York and pursue careers with Pan Am. Dorothy went to work in 1948, while Edna and Bernie became stewardesses in 1949 and 1957.[115] Along with Alice, they became known as the "Flying Lemieux Sisters." The four sisters not only worked for the airlines, but they also all married pilots. It was after one overseas flight that Lemieux met her husband-to-be, a Pan Am pilot with whom she had never flown: George Jacobsen.

Instantly smitten while giving Lemieux and several others a ride home in the rain, George invited her to a party, and she accepted.[116] They were married in 1948. As a wedding gift, one of Lemieux's former passengers planned and paid for their elaborate wedding reception at the Vanderbilt Hotel in New York.

Married women, however, were not permitted to work as stewardesses. But the new Mrs. Jacobsen would not have had time even if she had wished to continue: George was a widower and already the father of a spirited three-year-old boy. She thus became a stay-at-home stepmother to George Jr. and later had two more children, Rod and Kathy. The family lived in Montana, New York and Connecticut over the years, and though she continued to fly all over the world with Pan Am, it was as a seated passenger and not as the popular, hardworking air hostess.

In the summer of 2009, with a beauty and humble spirit that still charm just one month from her eighty-eighth birthday, she looked with wonder at the neat scrapbooks that her father assembled. They were filled with news clippings, photographs and details of her life as a flight attendant with Pan Am.

"I can't believe that it was all that long ago," she said with a wistful smile.

Gifted Actress, Mother, Writer

Beverly Hope Jensen (1953–2003)

Beverly Jensen's mother was a gifted storyteller. In an understated, country tone, Idella Jensen occasionally spoke to her four daughters of her New Brunswick childhood, of the death of her mother when she was only seven years old, of her arrival in Maine in about 1918 and of the years spent living with her aunt and uncle and their six sons in Scarborough. She spoke of the trolleys, the woods, of learning to cook for a family in Portland and of her marriage to Edward Jensen in 1931.

Little did Idella know that her gift for storytelling would be passed on to her fourth and youngest daughter, a daughter born when she was nearly forty-five years old. Idella's tales would find fertile ground in young Beverly's imagination; those vivid details of days long past, the places, the sounds, the times themselves would one day mature into a whole new world, complete with an array of vibrant yet flawed and very human characters. Beverly eventually cultivated those kernels into a masterpiece of historical fiction, humorous yet raw and realistic stories that would one day win the respect of the national literary community and a place in the 2007 edition of *America's Best Short Stories*, coedited by Maine's own Stephen King.

And Beverly Jensen hadn't even planned to be a writer.

Born on July 17, 1953, Beverly Hope Jensen was the daughter of Idella (Hillock) and Edward Jensen of Westbrook. The baby of the family, she was raised along with her three elder sisters, Barbara, Donna and Paulette, in her family's Longfellow Street home near her parents' corner convenience shop and the lands that once held her Danish grandfather's dairy farm. She went to Westbrook schools through graduation in 1971, cultivating a love of theatre from a young age. From childhood performances with her friends to starring in plays with the dramatics club throughout high school, Jensen had decided early on that she wanted to be an actor.

Bright and outgoing, Jensen was also an observer. She loved listening to family stories, attending gatherings and watching, absorbing the voices, scenes and gestures around her.[117] The family store, where she helped out occasionally after school, was part of her world and another good place for soaking in the intricacies and intrigue of life in the Paper City.

After high school, she attended the University of Maine, following her dreams with a major in theatre and obtaining her BA in 1975. She then went on to Southern Methodist University, a leader in the study of performing arts, to pursue an MFA, which she received just two years later. "And she was very, very good," says her husband, Jay Silverman, with a smile.[118] Upon graduation, she was selected in a national competition for an audition with the League of Resident Theatres, a well-known professional theatre association spread throughout the country.[119]

What Jensen most loved about acting, recounts Silverman of New York, was the research, the preparation for a character, finding her voice. She loved working with the nuances of speech, dialects, expressing her characters through words as well as gesture and expression.[120]

Jensen went on to act for three seasons with the Barter Theatre in Abingdon, Virginia, a seventy-five-year-old company that gave an early home to many actors of future fame including Ernest Borgnine, Gregory Peck and, more recently, Wayne Knight, who starred as Newman the postal worker in the 1990s sitcom *Seinfeld* as well as in the blockbuster film *Jurassic Park*. She also acted at Colorado's much-respected Creede Repertory Theater in 1976, among other places across the country. Jensen continued to act in many regional theatre productions after moving to New York City in 1978 and had the opportunity to study with acting coach Larry Moss, the

much-sought-after instructor who has since worked with leading stars such as Helen Hunt, Leonardo DiCaprio and Jim Carrey.

"Her work in that class was, in her view, the pinnacle of her career in that she was able to most fully explore character, scene and text," writes husband Jay. "She liked to say that if the character carried a purse but never opened it, the actress still needed to know everything inside."[121]

It was in Abingdon that Jensen first met Silverman, a young English professor who would become her husband in 1984. Silverman had seen her in several plays and, through a friend, the director of one of Jensen's performances, was introduced at an ice cream party that summer. Their first date was at the close of one of her performances, and Jensen's birthday. "And that was it," says Silverman. He taught her to swim that summer, and they would remain together for the rest of Jensen's too short life.

Jensen eventually moved to New York to pursue her acting and was soon joined by Silverman, who found a teaching position at Long Island's Nassau Community College. Jensen continued to act for several years after the couple married, but the networking and "politics" necessary for a successful acting career had always been Jensen's least favorite aspects of theatre.[122]

Beverly Jensen. *Courtesy of Jay Silverman, http://www.beverlyjensen.net*

Her passion was for good plays with good people, the training, the art. When she and Silverman chose to have children, Jensen decided that the travel and necessary self-promotion that accompany a career in the performing arts did not correspond with her goals as a parent.

Her son Noah was born in 1987 and daughter Hannah in 1993, and Jensen fell in love with motherhood, with reading to her children, with art projects, with everything about being a parent. Meanwhile, her love of theatre and her love of character, scene and text found a new outlet in writing—when she had the time. Jensen eventually established a very tight writing schedule while her children were off at school each morning, typing quickly while her imagination filled with the voices of two sisters, inviting Jensen to accompany them for a few hours each day on their adventures. These sisters were named after her mother and aunt, Idella and Avis, and their tales were set in a different time, outside of the city, in places much like those her mother had told her about in her stories. They reflected the streets and buildings, woods and streams of Westbrook, the city in which she had grown up, the one in which she had spent so many years observing.

Using a historical framework and many of the personality characteristics of her mother and aunt, Jensen pieced together tales that would make her laugh out loud or cringe from their harshness. Determined to make the historical details believable, Jensen and Silverman, a loving and encouraging supporter of her craft, would travel to Maine and spend hours recording her mother's stories, encouraging details from her about her days as a young woman in Maine. Jensen, as she had in theatre, wanted to know about every item that was in her characters' purses.

Jensen continued to shape her stories for sixteen years, never having the time for the business aspect of becoming a published author—the cover letters, queries and rejections that take up a good percent of any professional writer's work time. She shared her stories with her husband each night, and on weekends when time allowed they would work together on line editing and fixing the inevitable typos produced by her lightning fast typing.[123] "She shared some stories with her sisters and friends," writes Silverman, "but the reward for her was never the praise of others. She loved writing the stories, seeing what came from within her and what she could make of it."[124]

In 2000 and 2001, Jensen finally enrolled in several creative writing courses with author and instructor Jenifer Levin. She was pleased and encouraged

to receive Levin's and the other student writers' enthusiastic comments regarding her characters, her voice, her settings. "It was impossible not to recognize the sheer beauty of her art," Levin said in a later interview.[125] As she had with acting, Jensen loved the hard work, the study of the craft, the training that went into writing and revision. Levin told her that, without doubt, her stories would one day be published.

Sadly, however, Jensen would not live to see that happen. She was diagnosed with pancreatic cancer in 2003 and passed away the following summer while on vacation with her family at a favorite cabin on Crescent Lake, just several days before her fiftieth birthday. One of the last activities she shared with her husband and children was swimming—the skill Silverman had taught her during their first summer together. After her death, her husband and her friend and teacher Levin, both recognizing the depth of her writing talent, decided to gather her work and sent some excerpts off to literary magazines for consideration.

Modern fiction writers know that publication—especially in the genre of fiction—is no easy task for an unknown writer. Jensen's first submitted story, "Wake," however, quickly found a home in the *New England Review*, a journal that finds itself on the wish list of many new—and many already accomplished—writers. "Wake" is a tale of a quirky and often inebriated pair of siblings accompanying the remains of their father from Connecticut to Canada for his funeral. "Good God Almighty. We've lost the damned body," it begins and pulls the reader along craftfully from then on, hitting voice spot on, letting subtle details show the depth of the characters and transporting the reader back in time.

"Wake" was later selected by coeditors Stephen King and Heidi Pitlor for inclusion in *The Best American Short Stories* (2007). Several other stories were then published, including "Gone," "Pan Fried" (*New England Review*) and "Idella's Dress" (in the Paris Press anthology *Sisters*). The entire collection was then picked up by Viking Press for publication under the title of *The Sisters of Hardscrabble Bay*, due out this summer (2010). Jensen's stories make one laugh with such brilliant and authentic dialogue lines as "And quit your roaming! It's like talking to a fly in a manure pile," and tug at the heartstrings with scenes of family strife, shame and sadness.

Though Jensen did not live to see her work reach public success, or have the chance to enjoy her nomination for a Pushcart Prize by Joyce Carol

Oates, or read Stephen King and Elizabeth Strout's words of enthusiasm for her creation, her husband and children are proud that Beverly Jensen's voice, her love of character and the fruits of sixteen years of work have been shared with the world.

Notes

MAST AGENT WHO STARTED WAR DIES PAUPER BUT LEAVES MARK ON CITY OF WESTBROOK

1. Clark, *Maine*, 39.
2. Willis, *History of Portland*, 288.
3. *Story of Maine*, videocassette.
4. Ketover. *Fabius M. Ray*, 160.
5. Williamson, "Waldo's Sales Talk Brought German Families to Grief."

LEGACY OF CITY'S BENEFACTOR

6. Scontras, "Non-Adversarial Labor Relations," 17.
7. Weigle, *Presence in the Community*, 1.
8. Scontras, "Non-Adversarial Labor Relations," 4–5.
9. Ibid., 4.
10. Ibid., 6.
11. Weigle, *Presence in the Community*, 9.

Sculptor's Quest for Beauty Cut Short

12. O'Brien, "Paul Akers."
13. Ibid.

Historian Told City's Story through Research

14. Ketover, *Fabius M. Ray*, xii.

City Celebrates Warp Mill Founder

15. Swann, *Woodbury Kidder Dana*, 39.
16. Ibid., 43.
17. Ibid., 44.
18. Ibid., 63.
19. *Daily Eastern Argus*, "Parade 500 School Children."

Former Prisoner of War Becomes One of Westbrook's Most Beloved Citizens

20. Ransom, *Andersonville Diary*, 280.
21. Warren, "Release from the Bull Pen," 132–33.
22. Ibid., 134.
23. *Daily Eastern Argus*, "Veteran of Civil War."
24. Ransom, *Andersonville Diary*, 117.

City Home to Early Baseball Superstar

25. Scruggs, "Piano Legs."
26. "Gorham Man Discoverer of George Gore of Baseball Fame," *Portland Evening Express*, date unknown.
27. *New York Times*, "Gore to Play Here."

28. Scruggs, "Piano Legs."

29. Charlton, et al, *Baseball Chronology.*

30. Scruggs, "Piano Legs."

PHILANTHROPIST, NOVELIST AND ADVOCATE OF WOMEN, YOUTH AND IMMIGRANTS

31. "Denison House."

32. Ibid.

33. Ross and White, *Cedar Hill Memories*, 11.

34. Ibid., 6.

35. Weigle, *Presence in the Community,* 13.

36. Scott, "Who Was Cornelia Warren?"

37. *Free Press*, "Miss Warren's Will."

THE MAN BEHIND THE BUILDING: BUSINESSMAN, LEGISLATOR, REFORMER

38. *Daily Eastern Argus*, "Hon. John Clark Scates."

39. Maine Historical Society, *Maine: A History.*

40. Ibid.

41. *Daily Eastern Argus*, "Hon. John Clark Scates."

42. Ibid.

43. Ibid.

INVENTOR'S CAREER BEGAN WITH BROKEN WINDOW

44. *Portland Evening Express & Advertiser*, "Portland Firm Ships Fibre Pipe."

45. Sinclair, "Westbrook Inventor."

46. Ibid.

47. "Fairbanks History."

48. *Portland Evening Express & Advertiser*, "Portland Firm Ships Fibre."

49. Sinclair, "Westbrook Inventor."

NURSE DIDN'T SHY FROM HORRORS OF WORLD WAR I

50. *Portland Evening Express*, "Decormier Funeral Held."
51. DeCormier, "Attestation Paper."
52. "In Flanders Fields."

"GINGER" FRASER: RESPECTED SOLDIER, TEACHER, COACH

53. Marriner, *History of Colby College*, 513.
54. Mitchell, interview by author.
55. Ibid.
56. Fraser, interview by author.
57. Billings, "Influenza Pandemic."
58. Fraser to Mr. and Mrs. Robert Fraser.
59. Fraser, interview by author.
60. Fraser Family binder.

A WOMAN IN TWO WORLD WARS: HELLO GIRL HERO TO BIZERTE PRISONER

61. *Portland Evening Express*, "Former Westbrook Woman Gives Eye-Witness Account."
62. Christides, "Answering the Call."
63. Ibid.
64. Ibid.
65. *Portland Evening Express*, "Former Westbrook Woman Gives Eye-Witness Account."
66. *Portland Evening Express*, "Mrs. Herve Simon."
67. "November 1942: Operation Torch."
68. United States Holocaust Memorial Museum, "Jews of North Africa."
69. Satloff, *Among the Righteous*, 97.
70. Guez, *Au Camp de Bizerte*.

71. *Portland Evening Express*, "Mrs. Herve Simon."
72. "WWI Phone Girl Honored as Veteran."

A Remarkable Life Indeed

73. Price and Talbot, *Maine's Visible Black History*, xiii.
74. Barry, foreword to *Maine's Visible Black History*, xi.
75. Magill, "Panic at the French Quarter Wharves."
76. Wu, "Veteran Celebrates 108th Birthday."
77. Westbrook High School, *Blue and White*.
78. Brown and Paisner, *Price of Their Blood*, 128.
79. Ibid., 131.
80. Ibid., 132.
81. Ibid.
82. Ibid., 133.
83. Ibid., 134.
84. Wescott, "Happy Birthday, Dolly."
85. Wu, "Veteran Celebrates 108th Birthday."
86. Lowell, "Alfred Pugh Dies."
87. Brown and Paisner, *Price of Their Blood*, 127.
88. Lowell, "Alfred Pugh Dies."

Maine Swooned at Crooner's Return

89. Vallee and McKean, *My Time Is Your Time*, 57.
90. Vallee, *Vagabond Dreams Come True*, 103.
91. Vallee and McKean, *My Time Is Your Time*.

City-Raised Nun Witnessed Major Change in China

92. Grondin, "I Was a Captive."
93. Hey, interview by author.

94. Zimmet, "A Call, Very Strong."

95. Grondin, "I Was a Captive."

96. Ibid.

97. Ibid.

98. Zimmet, "A Call, Very Strong."

FUNERAL DIRECTOR FIGHTS URBAN RENEWAL—AND WINS

99. Eaton, interview by author.

100. Cor Kwant, "History."

101. Hay, Bird and Hurd, interviews by author.

102. Ibid.

103. Ibid.

104. Ibid.

105. Ibid.

106. Walker Memorial Library, "John Hay Oral History Transcript."

BIG DREAMS COME TRUE FOR PIONEERING AIR HOSTESS

107. Jacobsen, interview by author.

108. Saunders, interview by author.

109. Jacobsen, interview by author.

110. *Portland Evening Express*, "Local Airline Stewardess Flies."

111. Ibid.

112. Morris, "Tragedy and Rescue."

113. *Portland Evening Express*, "Local Airline Stewardess Flies."

114. *Portland Evening Express*, "Westbrook Stewardess Wins Place."

115. Jacobsen, interview by author.

116. Ibid.

GIFTED ACTRESS, MOTHER, WRITER

117. Silverman, interviews by author.
118. Ibid.
119. Silverman, "Beverly's Life."
120. Silverman, interviews by author.
121. Silverman, "Beverly's Life."
122. Silverman, interviews by author.
123. Tyree, "Finding Beverly," 26.
124. Silverman, "Beverly's Life."
125. Tyree, "Finding Beverly."

Bibliography

ARCHIVES AND SPECIAL COLLECTIONS

Conant Collections, private collection of Eleanor Conant Saunders, Westbrook, Maine.

Maine Historical Society Research Library, Portland, Maine.

Walker Memorial Library Local History Room, Walker Memorial Library, Westbrook, Maine.

Westbrook Historical Society Archives, Westbrook, Maine.

BOOKS, ARTICLES AND OTHER MATERIALS

"Andersonville: National Historic Site, Georgia." National Park Service, U.S. Department of the Interior, December 24, 2009. http://www.nps.gov/ande/index.htm.

Annual School Report of the City of Portland, 1904. Portland, ME: Marks Printing House, 1905.

Barry, William David. Foreword to *Maine's Visible Black History: The First Chronicle of Its People*, by Harriet H. Price and Gerald Talbot, xi–xii. Gardiner, ME: Tilbury House, Publishers, 2006.

Bennett, Charles A., ed. *Manual Training Magazine* (November 27, 1899): 1–2.

Berg, Claire. Interview by the author. Westbrook, ME. July 2009.

Billings, Molly. "The Influenza Pandemic of 1918." Human Virology at Stanford, February 2005. http://virus.stanford.edu/uda.

Born, Vaun. "Cornelia L. Warren: Friend and Benefactor." Unpublished. Westbrook Historical Society Collections, 1998.

Boyle-Durgin, Mary Louise. *Odyssey of Love.* Dixfield, ME: Marylee Publishers, 1994.

Brown Bulletin 3, no. 9. "Inventor of Fibre Conduit Dies: Pioneered Industry Here." May 31, 1950, 1.

Brown, Jessie, and Daniel Paisner. *The Price of Their Blood: Profiles in Spirit.* Chicago: Bonus Books, 2003.

Burrage, Henry Sweetser, and Albert Roscoe Stubbs. *Genealogical and Family History of the State of Maine*, vol. 4. New York: Lewis Historical Publishing Company, 1909, 2105.

"The Cargo for Cadiz: Tube Mill Ships Record Order to Ancient City Founded by Tyrian Merchants." *Brown Bulletin* 7, no. 2 (August 1, 1925): 11–12.

Carroll, Andrew, ed. *War Letters: Extraordinary Correspondence from American Wars.* New York: Washington Square Press, 2002.

"Challenging the World by Changing Expectations." Pratt & Whitney, a United Technologies Company. http://www.pw.utc.com/About+Us/History.

Chapin, Florence M. "Cedar Hill News: Cornelia Warren 1857–1921." *The Trail Maker* (March 1928): 19–20.

Charlton, James, et al. *Baseball Chronology: The Complete History of Significant Events in the Game of Baseball.* New York: Macmillan Publishing Company, 1991. http://www.baseballlibrary.com/chronology.

Christides, Michelle. "Answering the Call: The History of the First Women Combatants Sworn into the U.S. Army in WWI." Unpublished manuscript. Excerpts available at http://www.jungsoul.com/Hello-Girl.html.

Clark, Charles E. *Maine: A History*. New York: W.W. Norton & Company, Inc., 1977.

Coburn, Isabel T. "The Westbrook Secret: A Skeleton in the Woods Solves a 232 Year Old Mystery." *Evening Express* (Portland, ME). July 27, 1976.

"Commodore Perry and the Opening of Japan." U.S. Navy Museum, January 2010. http://www.history.navy.mil/branches/teach/ends/opening.htm.

Connelly, William Elsey. *A Standard History of Kansas and Kansans*, vol. 3. Chicago: Lewis Publishing Co., 1918.

Corey, Patricia Bowden. *Owascoag: Place of Much Grass, The Settlement of Black Poynt, Mayne, In the Settlers Own Words, 1605–1800*. South Portland, ME, 2006.

Crowe, Mike. "The King's Broad Arrow—Pine and Tea." *Fishermen's Voice* 12, no. 12 (Goldsboro, ME), December 2007. http://www.fishermensvoice.com/archives/1207index.html.

Daily Eastern Argus (Portland, Maine). "Hon. John Clark Scates Named for Congress." July 30, 1908.

———. "Parade 500 School Children Feature Dana Celebration, Westbrook Yesterday." June 8, 1916.

———. "Veteran of Civil War, Former Member of Legislature and Philanthropist." August 13, 1915.

DeCormier, Cora A. "Attestation Paper, Canadian Overseas Expeditionary Force." Soldiers of the First World War—CEF. Library and Archives Canada, December 12, 2006. http://www.collectionscanada.gc.ca/databases/cef/001042-119.02-e.php?image_url=http://data2.archives.ca/cef/gpc002/289186a.gif&id_nbr=350776.

"Denison House." Open Collections Program: Immigration to the United States, 1789–1930. Harvard University Library, October 2006. http://ocp.hul.harvard.edu/immigration/organizations-Denison.html.

"Dummer's War." *The Oxford Essential Dictionary of the U.S. Military.* N.p.: 2001. March 8, 2010. http://www.encyclopedia.com/doc/1O63-DummersWar.html.

Eaton, Douglas (City of Westbrook Public Works Department). Interview by author. January 2010.

"Fairbanks History." *Fairbanks Scales Company.* http://www.fairbanks.com/history.asp.

Fraser, Charles. Interview by author. Centerville, MA. December 2009.

Fraser Family binder. Collections of Westbrook Historical Society Archives. Westbrook, ME.

Fraser, Paul. Letter to Mr. and Mrs. Robert Fraser December 31, 1918. Private collection of Janet Mitchell Fraser, Waterville, ME.

Free Press (Waltham, Massachusetts). "Miss Warren's Will Filed at Cambridge." June 8, 1921.

"George Gore." Baseball-Reference.com, November 2009. http://www.baseball-reference.com/minors/player.cgi?id=gore--001geo.

"George Gore Stats." Baseball Almanac. http://www.baseball-almanac.com/players/player.php?p=gorege01.

"Gore to Play Here: Released by the Chicago Cubs to Join the New Yorks." *New York Times*, November 25, 1886. http://query.nytimes.com/mem/archive-free/pdf?_r=2&res=9E01E2D6123FE533A25756C2A9679D94679FD7CF.

Gratwick, Harry. "The Colorful Career of One of the State's Best Baseball Players." *The Working Waterfront*, April 2009. http://www.workingwaterfront.com/articles/The-colorful-career-of-one-of-the-states-best-baseball-players/13008.

Green, Martin. *The Mount Vernon Street Warrens: A Boston Story, 1860–1910.* New York: Scribner's, 1989.

Grondin, Therese (Sister Marie Marcelline). "I Was a Captive of Chinese Reds," edited by Walter E. Martell. *Portland Sunday Telegram.* December 28, 1952/January 4, 1953.

Guez, Jacob André. *Au Camp de Bizerte: Journal d'un Juif Tunisien Interné sous l'Occupation Allemande (1942–1943).* Paris, France: L'Harmattan, 2001.

Hay, Peter, Deborah Bird and Dorcas Hurd. Interviews by author. Westbrook, ME. February 2009.

Hey, Bess. Interview by author. Gorham, ME. July 2009.

Hiawatha News 1, no. 3. "Governor Morrill Dead." March 18, 1909. From the collections of the Brown County (Kansas) Genealogical Society.

Hinz, Lyle. "Way Back When." *Hiawatha, Kansas Daily World.* November 20, 1998.

"Important World War II Dates." Men of Honor of WWII. Men of Honor, Churchhill's Bunker, Dover Aviation Museum, South Pacific 1942–1945. The Imperial War Museum World War II. http://www.pslap.com/imperialwarmuseum.html.

"In Flanders Fields By Lieutenant Colonel John McCrae, MD (1872–1918) Canadian Army." Arlington National Cemetery, November 9, 2009. http://www.arlingtoncemetery.net/flanders.htm.

Jacobsen, Alice Lemieux, Kathy Jacobsen and Jane Wygant. Interview by author. Monmouth, ME. July 2009.

Kelly, Orr. *Meeting the Fox: The Allied Invasion of Africa, from Operation Torch to Kasserine Pass to Victory in Tunisia.* New York: John Wiley & Sons, Inc., 2002.

Ketover, Karen Sherman. *Fabius M. Ray's Story of Westbrook.* Westminster, MD: Heritage Books, 1998.

Knox, Richard. "1918 Killer Flu Reconstructed." NPR, December 2000. http://www.npr.org/templates/story/story.php?storyId=4946718.

Kwant, Cor. "History: A Living Fossil." The Ginkgo Pages, 2009. http://www.xs4all.nl/~kwanten/index.htm.

LaBorde, Larry. "Money Then and Now Part XII: The 1933 Banking Crisis." *Gold-Eagle.* January 13, 2005. http://www.gold-eagle.com/editorials_05/laborde011305.html.

Liljeholm, Lyn. "Old Tom Gets Reburial with 9 Generations on Hand." *Maine Sunday Telegram.* August 1, 1976.

Lovejoy, Myrtle Kittridge. *This Was Stroudwater, 1727–1860.* Portland, ME: National Society of Colonial Dames of America in This State of Maine, 1985.

Lowell, Robert. "Alfred Pugh Dies Just short of His 109 Birthday." *American Journal* (January 14, 2004).

Magill, John. "Panic at the French Quarter Wharves and Plague on St. Charles Avenue." Historic New Orleans Collection, May 2009: 19–20. Preservation Resource Center of New Orleans. http://www.prcno.org/programs/preservationinprint/Panic%20in%20the%20Quarter.pdf.

Maine Historical Society, American Historical Society. *Maine: A History, Centennial Edition, Biographical,* vol. 4. New York: American Historical Society, 1919: 23–24. http://books.google.com/books?id=rH95AAA AMAAJ&pg=PA24&lpg=PA24&dq=scates+lumber+fairfield&source =bl&ots=288zWCZhPi&sig=yyx85-rBUzOoE1xVnSm99iXoeMc&hl =en&ei=6BdOS5bYBZHnlAfJt_2NDQ&sa=X&oi=book_result&ct= result&resnum=1&ved=0CAcQ6AEwAA#v=onepage&q=scates%20 lumber%20fairfield&f=false.

Marriner, Ernest Cummings. *The History of Colby College.* Waterville, ME: Colby College Press, 1963.

Massachusetts Medical Society, New England Surgical Society. *The Boston Medical and Surgical Journal* 137 (September 2, 1897): 247.

McClure, Gene. "Warren Family Kind to Westbrook B-Ballers." *Maine Sunday Telegram.* March 7, 2004.

Miscellaneous Papers Regarding Colonel Westbrook. Unpublished. Westbrook Historical Society Collections, Westbrook, ME.

Mitchell, Janet Fraser. Interview by author, Waterville, ME. December 2009.

Morris, Lieutenant Colonel Ted Allan, United States Air Force (Retired). "Tragedy and Rescue: Oscar Oscar—Charlie Baker George, Sabena Airlines DC-4 Crash Near Gander Lake, Newfoundland, September, 1946." The Collected Articles and Photographs of Ted A. Morris, Lieutenant Colonel, U.S. Air Force, Retired, September 24, 2009. http://www.zianet.com/tmorris/GanderRescue.html.

"November 1942: Operation Torch." Olive-Drab, May 22, 2006. http://www.olive-drab.com/od_history_ww2_ops_battles_1942torch.php.

"The Obituary for George Gore." The DeadballEra.com: Where Every Player Is Safe at Home. Obit from *New York Times*, September 17, 1933. http://www.thedeadballera.com/Obits/Obits_G/Gore.George.Obit.html.

O'Brien, Rose. "Paul Akers, Almost Forgotten, Was One of Maine's Gifted Sons." *Lewiston Journal.* January 1867.

"People and Events: Bleeding Kansas, 1853–1861." Africans in America Resource Bank, PBS.org. http://www.pbs.org/wgbh/aia/part4/4p2952.html.

Portland Daily Press. "Westbrook Girl Is Given Rare Honor." July 4, 1997.

Portland Evening Express. "DeCormier Funeral Held." March 31, 1942.

———. "Former Westbrook Woman Gives Eye-Witness Account of Shelling: Mrs. Simon Writes about Oran Battle." January 26, 1941.

———. "Gorham Man Discoverer of George Gore of Baseball Fame." N.d.

———. "John Clark Scates, 90, Democratic Leader, Dies." May 1949.

———. "Local Airline Stewardess Flies with Harriman, Attends Crash Survivors." October 10, 1946.

———. "Mrs. Herve Simon, 47, of Westbrook Rescued form Bizerte Prison Camp." July 29, 1943.

———. "Nun Jailed by Reds Says Yanks Don't Realize Value of Freedom." N.d.

———. "Westbrook Stewardess Wins Place on Round-World Plane: Alice Lemieux One of Ten Picked for Historic Flight." N.d. Westbrook Historical Society Archives. Westbrook, ME.

Portland Evening Express & Advertiser. "Portland Firm Ships Fibre Pipe in Millions of Feet to Markets." September 14, 1925.

Portland Press Herald. "Paul F. 'Ginger' Fraser, Former Colby Athlete, Dies of Heart Attack: Widely-Known Coach and Athletic Director Was One of Maine's All-Time Football Luminaries, Teacher and Youth Leader." April 12, 1938.

———. "The Voice of the People: Paul F. Fraser." April 1938.

Portland Sunday Telegram. "Westbrook Couple Will Hold Open House on Their Golden Wedding Anniversary, Tuesday." January 3, 1937.

Prescott, Dorothy M. *Cornelia Warren and the Story of Cedar Hill.* Belmont, MA: Dorothy Prescott, 1958.

Price, Harriet H., and Gerald Talbot. *Maine's Visible Black History: The First Chronicle of Its People.* Gardiner, ME: Tilbury House, Publishers, 2006.

"Primary Documents in American History: The Kansas-Nebraska Act." Library of Congress, Web Guides, January 7, 2010. http://www.loc.gov/rr/program/bib/ourdocs/kansas.html.

"Primary Documents in American History: The Missouri Compromise." Library of Congress, Web Guides, January 7, 2010. http://www.loc.gov/rr/program/bib/ourdocs/Missouri.html.

Ransom, John L. *John Ransom's Andersonville Diary.* New York: Berkley, 1994.

Ross, Patricia M., and Diane M. White. *Cedar Hill Memories: The Warren Family and Girl Scouts in Waltham, Massachusetts.* Boston: 1996.

Rowe, Ernest R., and the Westbrook Women's Club. *Highlights of Westbrook History.* Portland, ME: Bowker Printing Co., 1952.

Satloff, Robert. *Among the Righteous: Lost Stories from the Holocaust's Long Reach into Arab Lands.* New York: PublicAffairs, 2006.

Saunders, Eleanor Conant. Multiple interviews by author, Westbrook, ME. May 2009–March 2010.

Scontras, Charles A. "Non-Adversarial Labor Relations in Nineteenth-Century Maine: The S.D. Warren Company." *Maine History* 37, nos. 1–2 (Summer–Fall 1997): 2–29.

Scott, Connie. "Who Was Cornelia Warren?" *Maine Sunday Telegram*. June 20, 1976.

Scruggs, Roberta. "Piano Legs Was in Tune with Baseball." *Portland Press Herald*. June 6, 1994.

"The Siege and Battle of Corinth: A New Kind of War." History and Culture, February 2, 2010. National Park Service, U.S. Department of the Interior. http://www.nps.gov/history/nr/twhp/wwwlps/lessons/113corinth/113corinth.htm.

Silverman, Jay. "Beverly's Life." The Sisters from Hardscrabble Bay: Beverly Jensen, January 2010. http://www.beverlyjensen.net.

————. Interviews by author, Raymond/Westbrook, ME. July 2009, March 2010.

Sinclair, Guy V. "Westbrook Inventor and Some of His Products." *Portland Sunday Telegram*. December 27, 1936.

Starbuck, Walter F. "Miss Cornelia Warren Called to Final Rest." *Free Press* (Waltham, Massachusetts). June 6, 1921.

The Story of Maine, The Frontier Wars: Violence on Maine's Frontier. Videocassette. Maine PBS, 2004.

Swann, Frank. *Woodbury Kidder Dana: A Biographical Sketch.* Providence, RI: Livermore, Knight & Co., 1908.

Topeka Daily Capital. "Legislators Cool to 13th Governor." October 16, 1975.

Triplet, William S. *A Youth in the Meuse-Argonne: A Memoir, 1917–1918.* Edited by Robert H. Ferrell. Columbia: University of Missouri Press, 2000.

Tyree, J.M. "Finding Beverly." *Poets & Writers Magazine* (January/February 2009): 23–27.

United States Holocaust Memorial Museum. "Jews of North Africa: Oppression and Resistance." Holocaust Encyclopedia. http://www. ushmm.org/wlc/article.php?lang=en&ModuleId=10007312.

Vallee, Eleanor, and Jill Amadio. *My Vagabond Lover: An Intimate Biography of Rudy Vallee*. Dallas, TX: Taylor Publishing, 1996.

Vallee, Rudy. *Vagabond Dreams Come True*. New York: Dutton, 1930.

Vallee, Rudy, and Gil McKean. *My Time Is Your Time: The Rudy Vallee Story*. New York: I. Obolensky, 1962.

———. *Rudy Vallee Kisses and Tells*. New York: Major Books, 1976.

Varney, George J. "History of Norridgewock, Maine." In *A Gazetteer of the State of Maine*, transcribed by Betsey S. Webber. Boston: B.B. Russell, 1886. http://history.rays-place.com/me/norridgewock-me.htm.

———. "History of Waldo County, Maine." In *A Gazetteer of the State of Maine*, transcribed by Betsey S. Webber. Boston: B.B. Russell, 1886. http://history.rays-place.com/me/waldo-cty-me.htm.

Walker Memorial Library. "John Hay Oral History Transcript." Walker Memorial Library Oral History Project. Westbrook, ME: unpublished, 1978.

Warren, John E. "Release from the Bull Pen: Andersonville, 1864." *Atlantic Monthly* 202 (November 1958): 130–38.

Warren's Standard. "Cumberland Mills Houses Called 'Distinguished Architecture of the 1800s.'" February 1975, 1, 2, 10.

Weigle, Anastasia S. *A Presence in the Community: The Warren Family Legacy*. Westbrook, ME: Warren Memorial Foundation and Cornelia Warren Community Association, 2000.

Wescott, Lawrence J. "Happy Birthday, Dolly." *American Journal*. December 3, 2003. Editorial section.

Westbrook High School. *The Blue and White* (1915). Westbrook Historical Society archives. Westbrook, ME.

Williamson, William H. "Waldo's Sales Talk Brought German Families to Grief." *American Journal* (Westbrook, ME). October 24, 1990.

Willis, William. *A History of Portland: A New Edition of the 1865 History.* Somersworth: New Hampshire Publishing Company, 1972.

Wu, Julianne. "Veteran Celebrates 108th Birthday." *St. Petersburg Times Online.* March 2, 2003. http://www.sptimes.com/2003/03/02/news_pf/SouthPinellas/Veteran_celebrates_10.shtml

"WWI Phone Girl Honored as Veteran." Newspaper unknown, November 15, 1978. From Conant Collections, private collections of Eleanor Conant Saunders, Westbrook, Maine.

Yellon, Al. "The Top 100 Cubs of All Time—#48 George Gore." Bleed Cubbie Blue: A Chicago Cubs Fan Community Since February 9, 2005, January 2, 2007. http://www.bleedcubbieblue.com/story/2007/1/2/164852/5362.

Zimmerman, Thomas. "Plessy v. Ferguson." Bowling Green State University, Spring 1997. http://www.bgsu.edu/departments/acs/1890s/plessy/plessy.html.

Zimmet, Abby. "A Call, Very Strong, Took Nun to Asian Life, Struggle." *Portland Press Herald.* August 14, 1995.

About the Author

Andrea Pacillo Vasquez was raised in South Portland, Maine. A teacher, journalist and novelist, Andrea is a graduate of Bowdoin College and the Stonecoast MFA program in creative writing at the University of Southern Maine. She also attended the *Lorenzo De'Medici Instituto d'Arte* in Florence, Italy, in 1994–95. Andrea is a member of the Westbrook Historical Society and the Maine Historical Society, and she lives with her family in Westbrook.

Photo by Helen Peppe Photography.

Visit us at
www.historypress.net